BROKEN SPIRITS

EBERHARD GRAMES

BROKEN SPIRITS

EDITION STEMMLE

To Charlotteville / Tobago

CONTENTS

BROKEN SPIRITS

Denis Bourgès

On the mantelpiece in my parents' home, even before I was born, stood a rounded blue stone about the size of a dog's head, rippled with quartz in patterns exactly like ocean spray. This sculpture hewn at random by nature was more precious to my parents than any expensive vase. For me, too, it was the most wonderful of stones, even though, living in Brittany, we were constantly surrounded by stones: the walls of the houses and fields, the beach, the craggy coastline and the paths trod by our feet. Perhaps this stone was the sign that made me collect and revere found objects as icons.

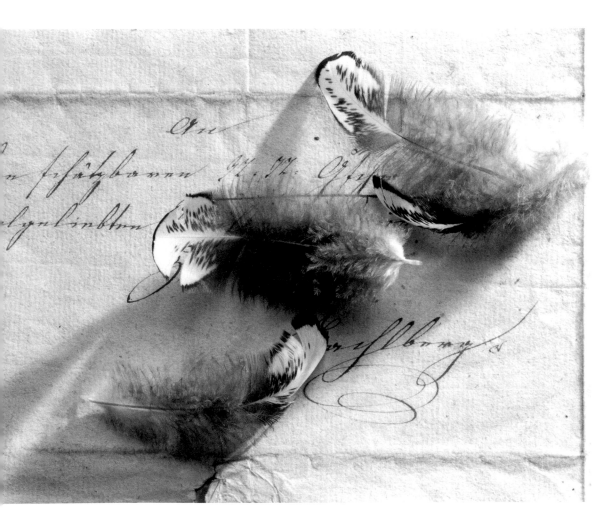

Feathers and Shades 1992

6

The rugged land and the rich sea harboured untold treasures for the inquiring eyes of a child. I collected all the curiosities that fell beneath my gaze: gull feathers, fish heads (which I took care to let the ants clean), fantastically distorted buoys, stones where oysters clung, pale driftwood weathered by the tides into ritual objects of some indigenous cult. From my window, I could see the outcrops of rock that appeared only at full moon and very low tide. This was the place where I collected my favourite shells: *ormeaux*, gracefully curved abalones lined with iridescent mother-of-pearl. The boys in our fishing village vied with each other to find particularly rare specimens of *Coquilles Saint Jacques*. We would spend hours combing through the heaps of discarded shells behind the fishmarket in search of a palm-sized scallop with black stripes on a pale pink or violet ground. These shells, like tablets inscribed with some ancient alphabet, were the coveted trophies of our hunt.

A reproduction of a small Rembrandt etching used to hang in our dining room at home. It was a black and white patterned shell, *conus marmoreus*, aesthetically pleasing in its simplicity. The artist had etched his name in mirror image on the metal plate so that it would read properly on the printed image. Because he had not bothered to do the same in etching the shell, he created a freak of nature: a shell that spirals anti-clockwise. This printed gem presided over every culinary adventure on which we embarked at that table, served up by my mother, an excellent cook. The shimmering scales of the fish, with their melancholy eyes that seemed to gaze out from beneath thick glass, the trailing tentacles of the squid – all this was part of the visual experience of each meal. Artichoke heads were torn apart and savoured, leaf by leaf, until we reached the most delicious part of all, the tender, soft-haired choke. By the end of this laborious and contemplative ritual, a huge pile of leaves had gathered in the middle of the table, a magnificent mound of waste as fascinating as a mound of spent oyster shells. Eating became a kind of artistic act, the creation of a profoundly aesthetic still life.

Later, on a visit to Japan, I was to rediscover the visual appeal of objects in even more concentrated form. In Japanese homes, I found once more the rounded stone of my parents' mantelpiece. But here, they were perfect works of art, placed upon a purpose built pedestal. These beautiful stones, known as *soseki*, reflect the miracle of nature in small, sculptural detail. They are displayed in niches, half-submerged in shadow, permitting communion with the spiritual essence of the stones. Such iconic reverence for nature and the inanimate object is as much a part of the Japanese soul as their utterly materialistic attitude to consumption. When the red maple leaves fall from the trees in autumn and the stoney streambeds are strewn with myriad russet stars, the Japanese go on pilgrimages to Arashiyama or Nikko to witness the serenity of this silently unfolding scene. Every schoolchild knows and reveres these places. In Japan, it is not the panoramic view that is considered worthy of contemplation, but the detail. The Zen monk sees the universe in every grain of sand.

Of course, in Japan, food is also treated as a priceless treasure. Eye and palate celebrate each bite as a sensual stimulus, each movement of the chopsticks to grasp sushi, sashimi or tempura becoming an act of visual concentration. The Japanese further enhance the sense of inherent artistry by packaging and presenting the objects of their desire so creatively that the item itself becomes almost insignificant. Packaging can transform an everyday object into a thing of value. A sweet, a leaf, a snail shell or a bottle-opener can become a precious momentary work of art. Given such a deeply rooted aesthetic and philosophical tradition, it is hardly surprising that the Japanese emperor should be a collector of nature's most beautiful objects: he possesses one of the world's largest collections of shells. Needless to say, what the Tenno collects also deserves the admiration of his subjects. Many Japanese people collect these beautiful shells that give shelter to such lowly creatures. In this land where small detail is writ large, a new form of meeting has developed amongst these shell collectors: inspiration. A few people gather to admire rare items presented by the collector. Each person present describes his personal visual experience, making comparisons and associations with the formal vocabulary of everyday life, art or nature. Presentation, seeing and inspiration thus become a ritual.

It was in Japan that I first saw the still life photographs by Eberhard Grames. Having admired such objects since my childhood, this was, for me, not only an intellectual experience, but also a profoundly personal one. Eberhard Grames has brought the bodies and the shells of animals, plants and stones in front of his camera and, in doing so, has created something that goes far beyond mere *nature morte* studies. His gaze is direct, analytical and uncluttered. Nevertheless, his sense of order and disorder triggers a number of associations and insights in the mind of the spectator. Some of his compositions have a positively illuminating effect on me. His reservoir of objects seems to have a boundlessly multicultural aspect that owes nothing to geographic space. He brings together items from a wide variety of cultures and lifestyles. In his *fine prints*, a simple object of nature becomes a brilliantly conceived work of art, observed through a magnifying glass. The *objet trouvé* becomes an *objet artistique*.

Many still life photographs by Grames are more than just sensual portrayals of objects. They are a *mise en scène* of the creative act, in which each protagonist has the opportunity of self-projection within the context of the image. Each object contributes its entire personality to the staging of the composition. Because Grames's camera makes no dramatic gestures of perspective or viewpoint, the objects are given the greatest possible scope for self-portrayal. As in FMR, the art magazine published by the Italian collector Franco Maria Ricci, *Broken Spirits* presents all the works of art in the same light and at the same visual level. The spectator is not holding the page of a book in his hand, but the object itself. And yet, the coincidence of objects is anything but an accumulation

of documentation; the world of each object and of each photograph is a *trompe l'oeil* world constructed by the photographer. I recall once, at a still life exhibition by Eberhard Grames, being drawn to a photograph of a white human ear against a dark ground. On closer inspection, I realised that I was actually looking at an oyster shell and a snail shell. Such consummate skill in the handling of associative form is also evident in *Like a Shark*, where no sharkfin cuts the surface of the sparkling sea; it is an owl's wing lying on a snakeskin.

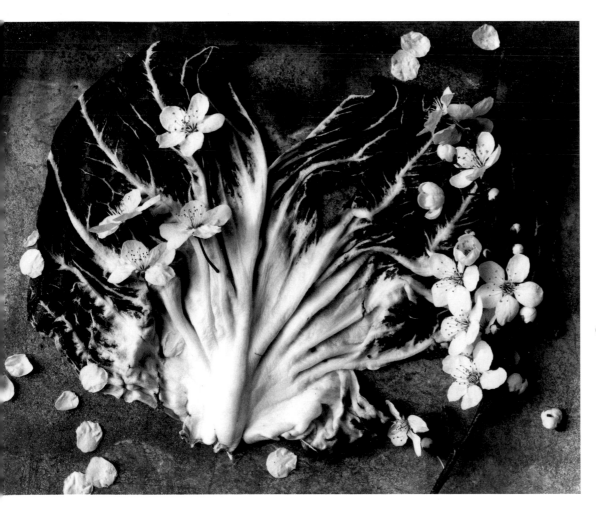

Cabbage Leaf and Blossoms 1993

I was particularly impressed by the still life with fish, where the photographer quite literally probes beneath the surface. A still life of fish generally tends to have rather more in common with food photography than with *nature morte*. Grames, however, has found a third approach: *nature vivante*. He uses wood grain, fruit, paper structures and snakeskins to simulate underwater worlds. Plants are bent by some invisible current. Twilight seems to break on the surface of the water and descend to the depths of the ocean, where fish move gracefully. In *Deep Sea Eyes*, a fluorescent fish seems to glide through a sea of bubbles, a fish eye amongst thousands of eyes. (Actually, it is simply a dead fish on the marbled paper of a book.) Details are selected with evocative care. The spectator has a sense of looking through the porthole of a submarine. The fish enters our field of vision from the right and, for a brief moment, we glimpse this coincidental scene, before the fish slips out of our field of vision again.

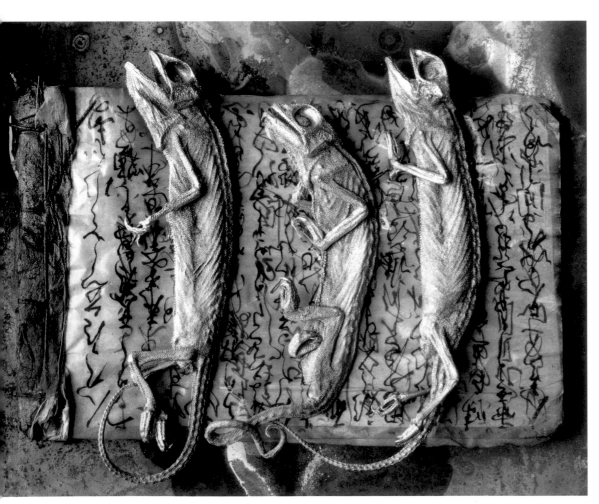

Chameleon Mummies 1992

Illusion and pretence have always played a major role in still life. For Grames, this has nothing to do with any intention to mislead, but with his quest to explore the essence of things, and to retain their compelling vitality, even in death. Nothing lends itself better to the presentation of a universal context than detail. Eberhard Grames, who has been to Japan many times and who has studied Zen philosophy, is a master of detail. In haiku poetry and in Japanese graphic art, the art of detail has been developed to the very highest level. The observation of detail is never vague, but invariably specific, using a small detail to reiterate the whole as a source of inspiration. The great Japanese masters of inkwash painting could lend bamboo an air of lightness with a fleetingly laconic brush and could capture the age and brittleness of a branch with a few swift, sure strokes.

The very special influence of Japanese thought and aesthetics is also evident in the way Eberhard Grames uses shadow in space. In his photographs of lizards, snakes, feathers, shells and blossoms, the subjects are defined by the vividness of shadow rather than by the volume of light. Grames never places his virtuoso handling of light in the foreground. He presents his objects in the light in which he sees them in his hands: in the soft natural light of the window. The Japanese writer Tanizaki's famous essay *In Praise of Shadow* describes the natural intimacy of objects presented in a space in which soft daylight creates gentle shadows. (In classical Japanese rooms, light is filtered through fine paper affixed to the window frames.) This consistent handling of light, and the use of an 8 x 10 camera, is the key to the textural density, tonality and vigour in the still life works of Eberhard Grames. As there is nothing to detract from the formal interplay of objects, the spectator can concentrate fully on interpreting the signs of the photographer. Objects are not packaged artificially, but allowed to develop the full power of their iconicity. In Japan, fruit and small treasures are isolated within their surroundings as sensual signs by placing them on a sheet of paper, a small wooden plate or a lacquered bowl, in the same way that Eberhard Grames isolates and emphasises his treasures from nature. He places them on books, in shells, on leaves, animal hides or pieces of wood. The packaging itself is, of course, more than just an outer covering; it is an object amongst objects in the interplay of visual energies.

Where the means to an end does not detract from the essence of the thing, and where the means does not become the end, but merely the evocative image, there is room for sensuality, for smells and sounds, for silence and illusion. In the photographs of Eberhard Grames, we can almost hear the lizard step on a blossom, the sound of the jungle where the serpent creeps. The flesh of the blossoms conjures up the image of all that blooms, the flesh of fish evokes all sea creatures, and soft downy feathers epitomise all that is birdlike. In *Snake Dance*, the snake appears to hover on the tip of a blossom. It is a moment of silence. All things are harmoniously balanced: the snake, the blossoms, the hairs of the hide. Everything, even the light, has a filigree quality of fragile tranquility.

It is difficult to discern the influence of European still life painting or collage in the work of Eberhard Grames. His floral studies are not decorative bouquets, but fetishistic presentations. His animals are not hunting trophies, but creatures of magical iconicity. Man-made products of everyday life and human craftsmanship are too artificial and unerotic for this artist to include them in his photographs. Though he has an intimate knowledge of every nuance of photographic style from Imogen Cunningham to Olivia Parker, he does not refer openly to it in any of his images. His is a new voice in still life photography, a hitherto unknown language that is more cultic than decorative. His objects are more like the fetishes of the medicine-man than the life studies of Albrecht Dürer or Maria Sibylla Merian. Grames sees the skin of natural objects as the magical power of a sign language that has yet to be decoded, rather than as a documentary study of nature. His snakes evoke poisonous twilight encounters rather than scientific records. To discover *Broken Spirits* is to discover the fascinating otherness that dwells in the art of creation, though what we encounter may be objects we think we have seen a thousand times before. The familiar faces of things seem to be shattered, revealing a glimpse of a world beyond pure objectivity. The tales this book tells of the things of nature are both invented and true. *Broken Spirits* is a sensual incantation, a spiritual invocation.

PLATES

Snake Dance 1995

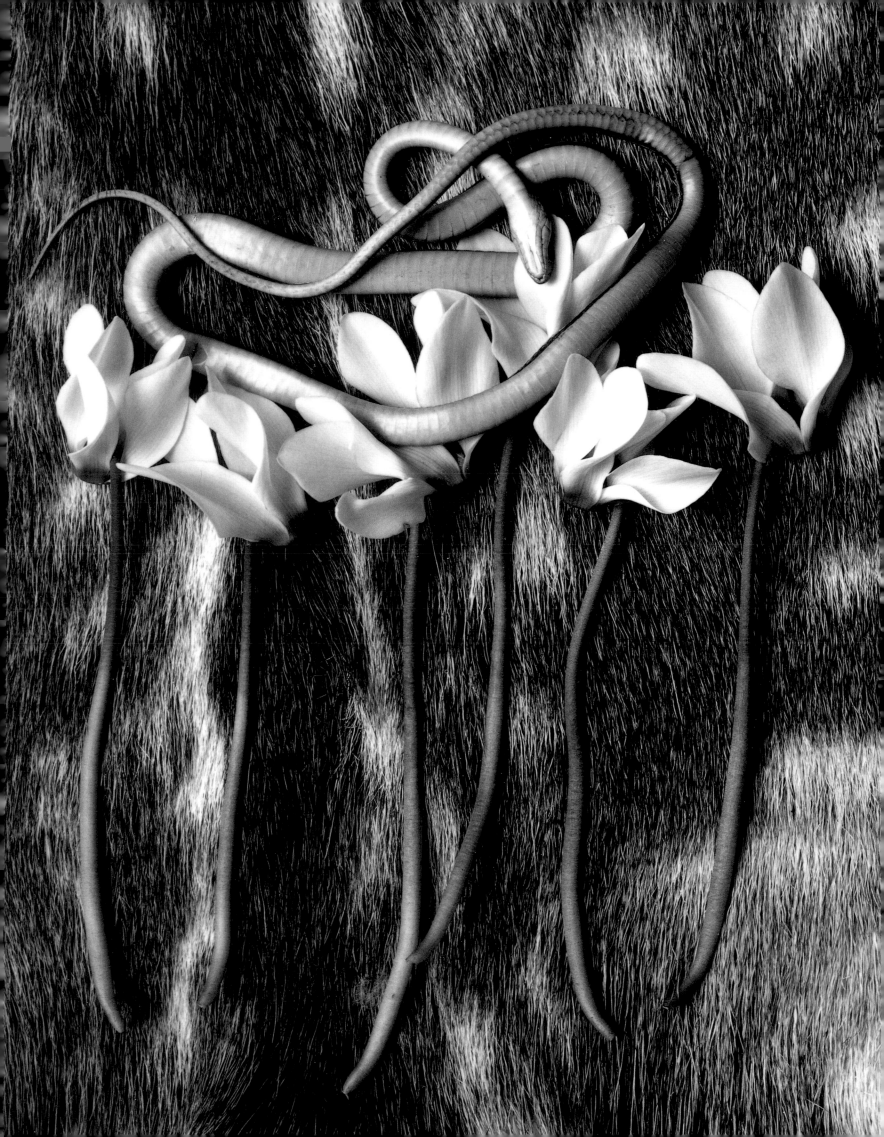

Broken Shell by Moonlight 1994

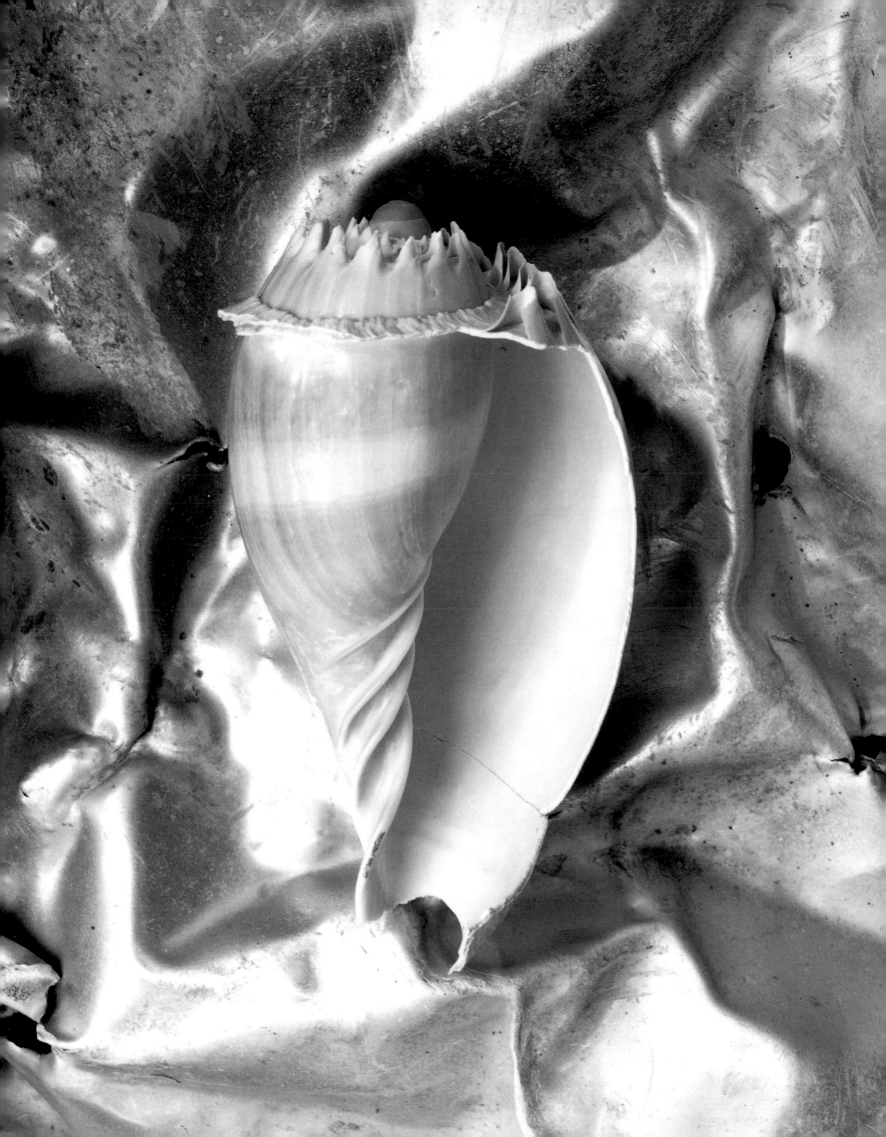

Feathers on Decorated Paper 1992

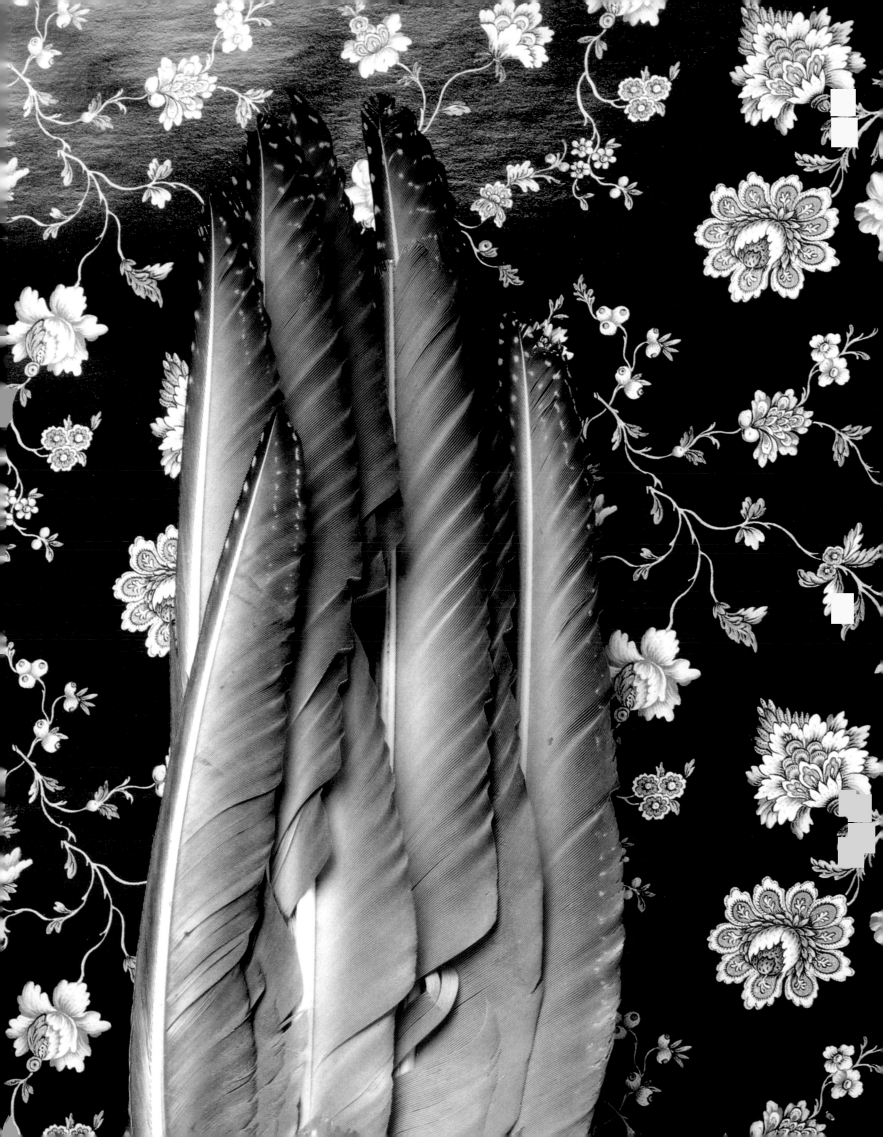

Orchids and Lizards 1990

Crying Lip Fish 1995

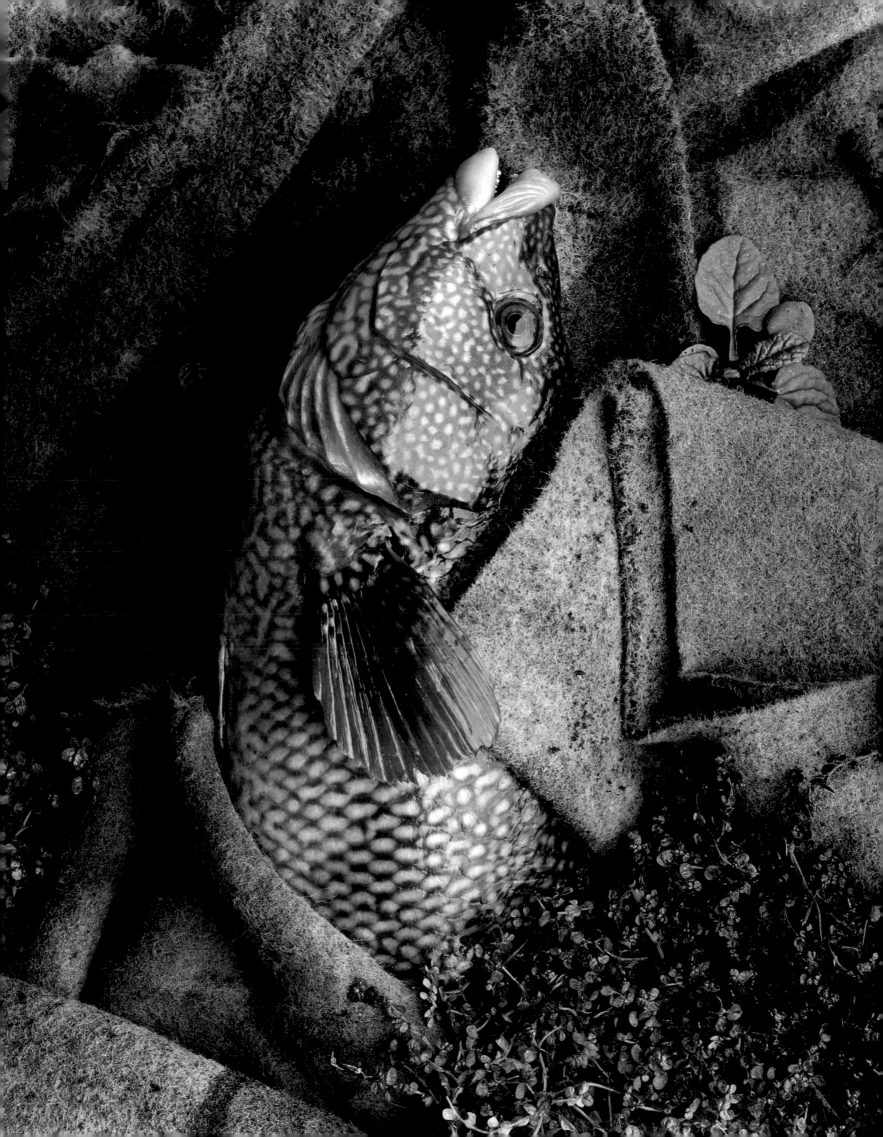

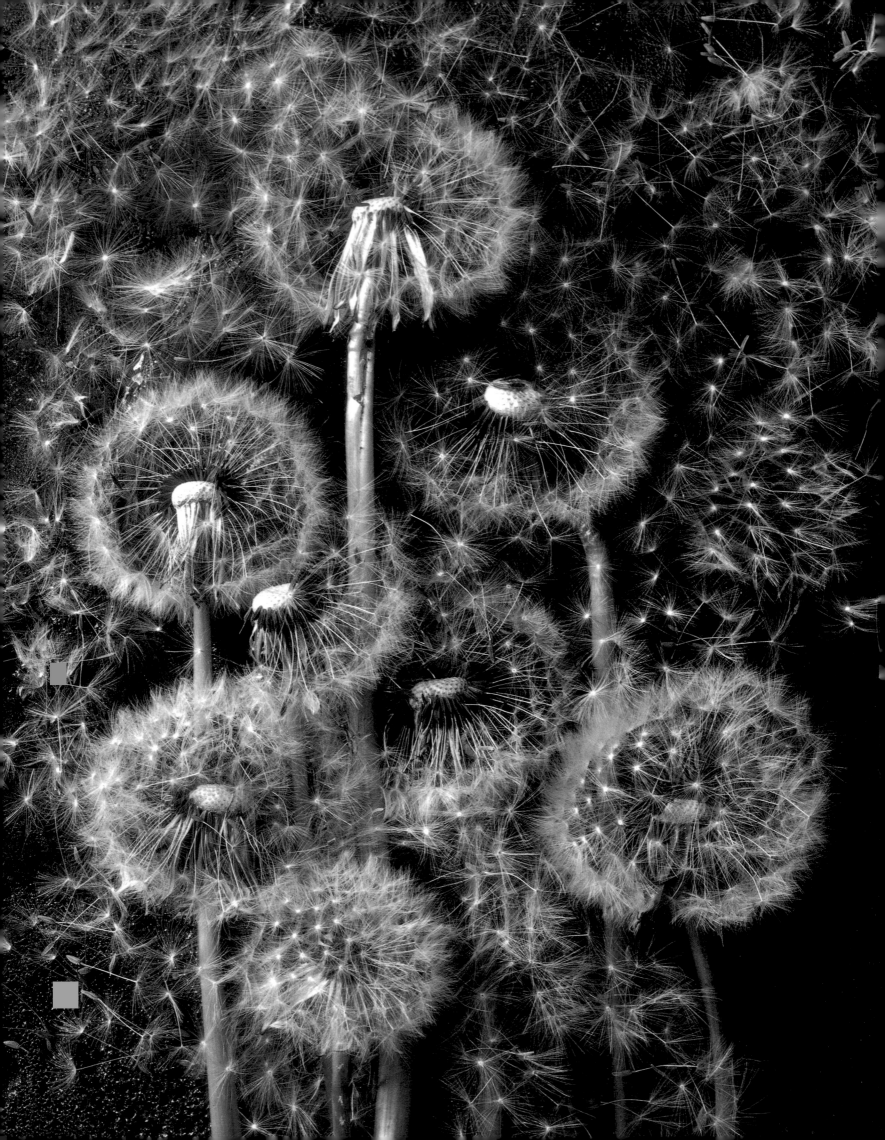

Blowing Wind 1995

Iguana Lovers 1990
Dry Current 1995
Marine Bouquet 1995

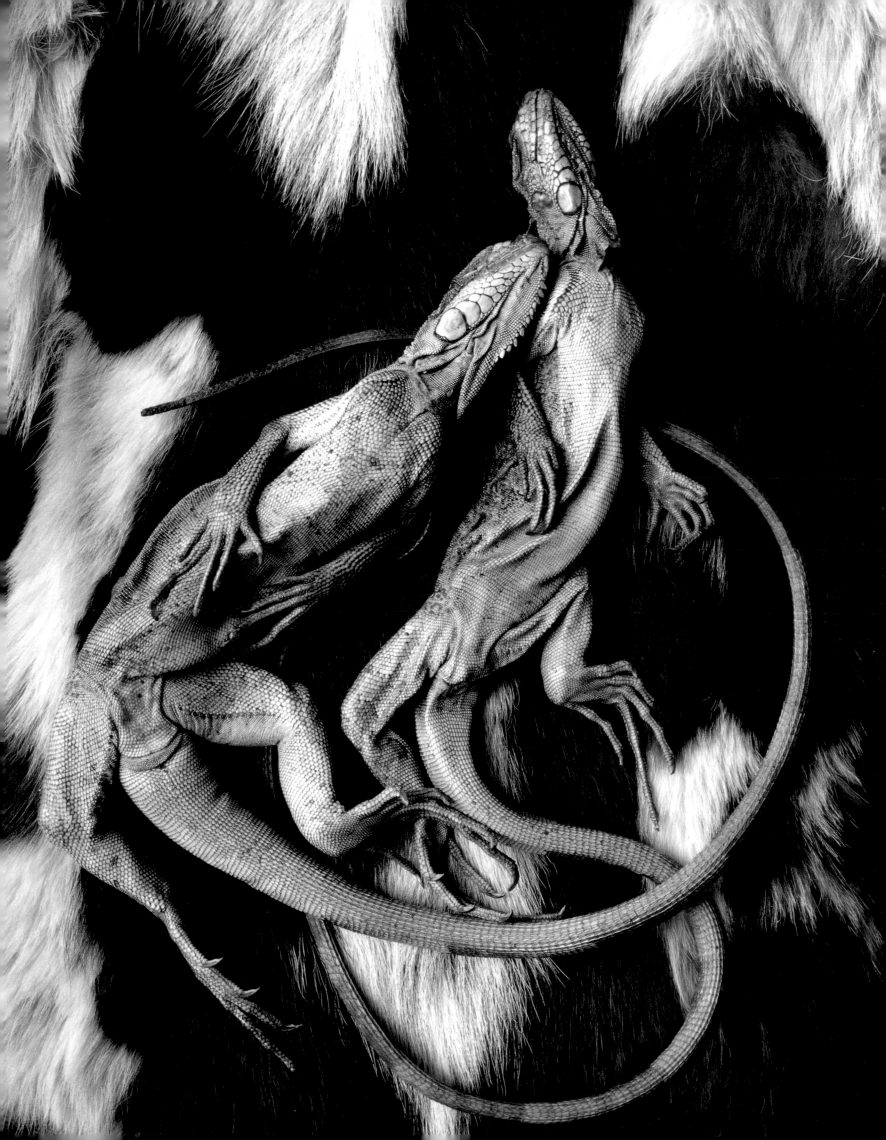

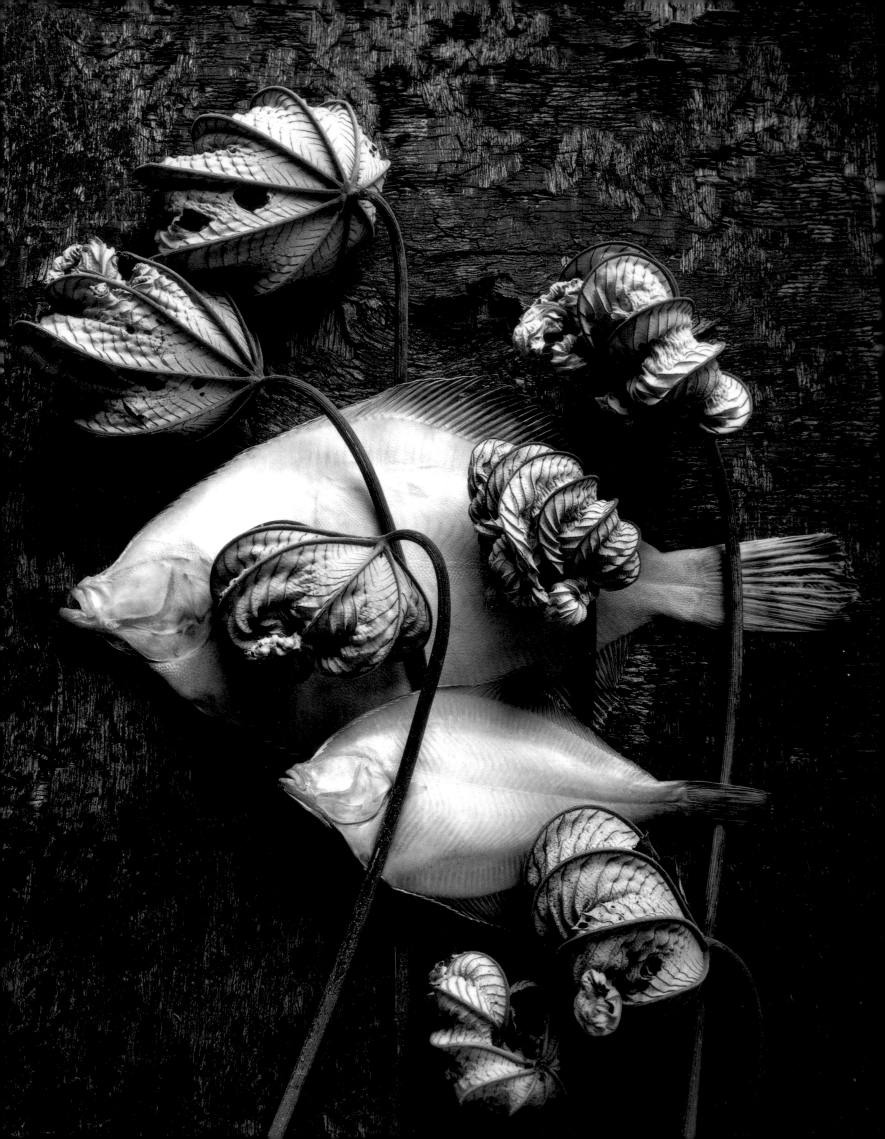

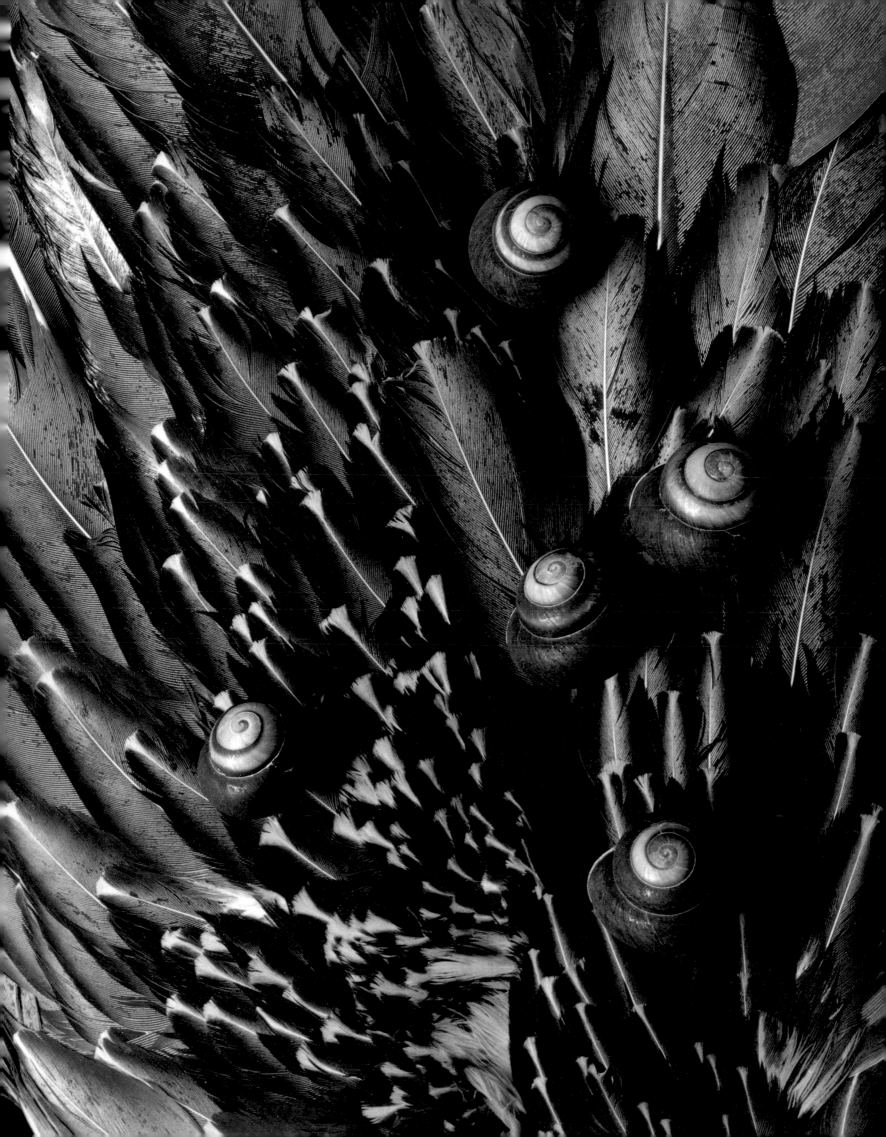

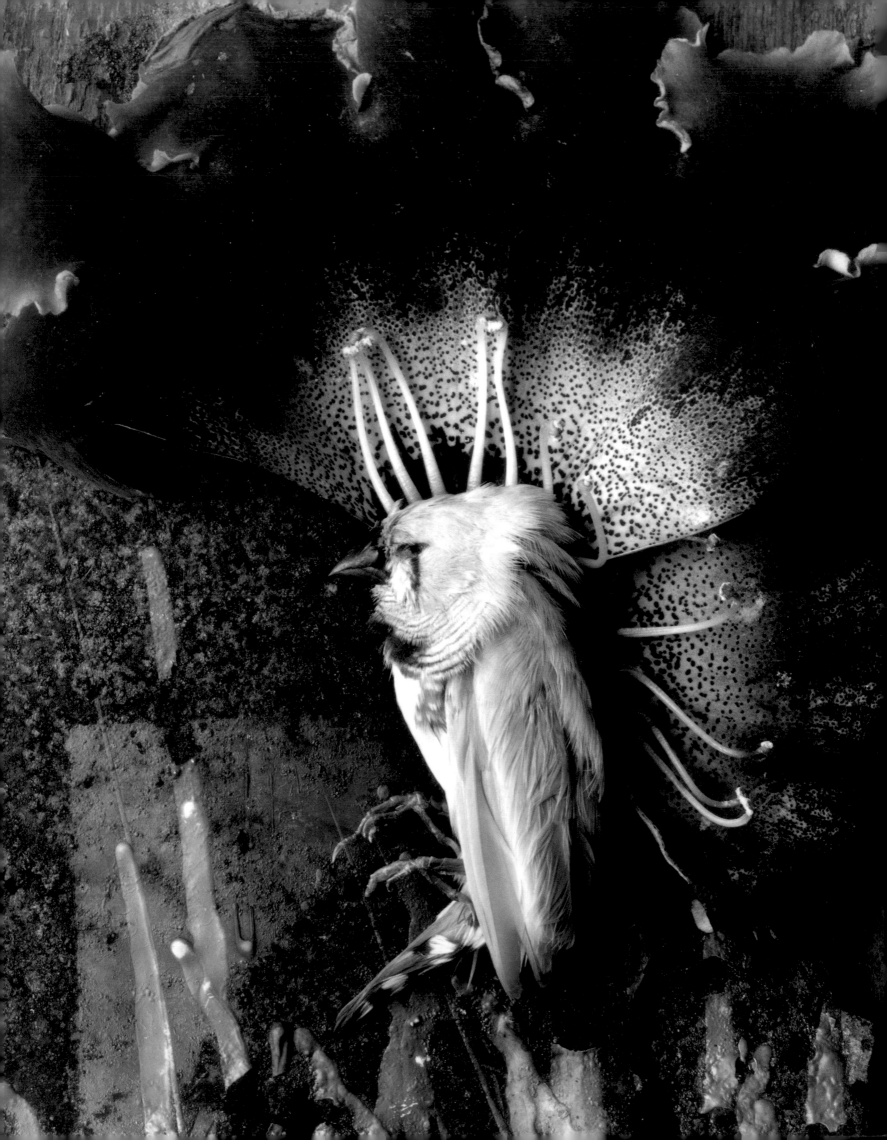

White Bird 1995

Like a Shark 1995

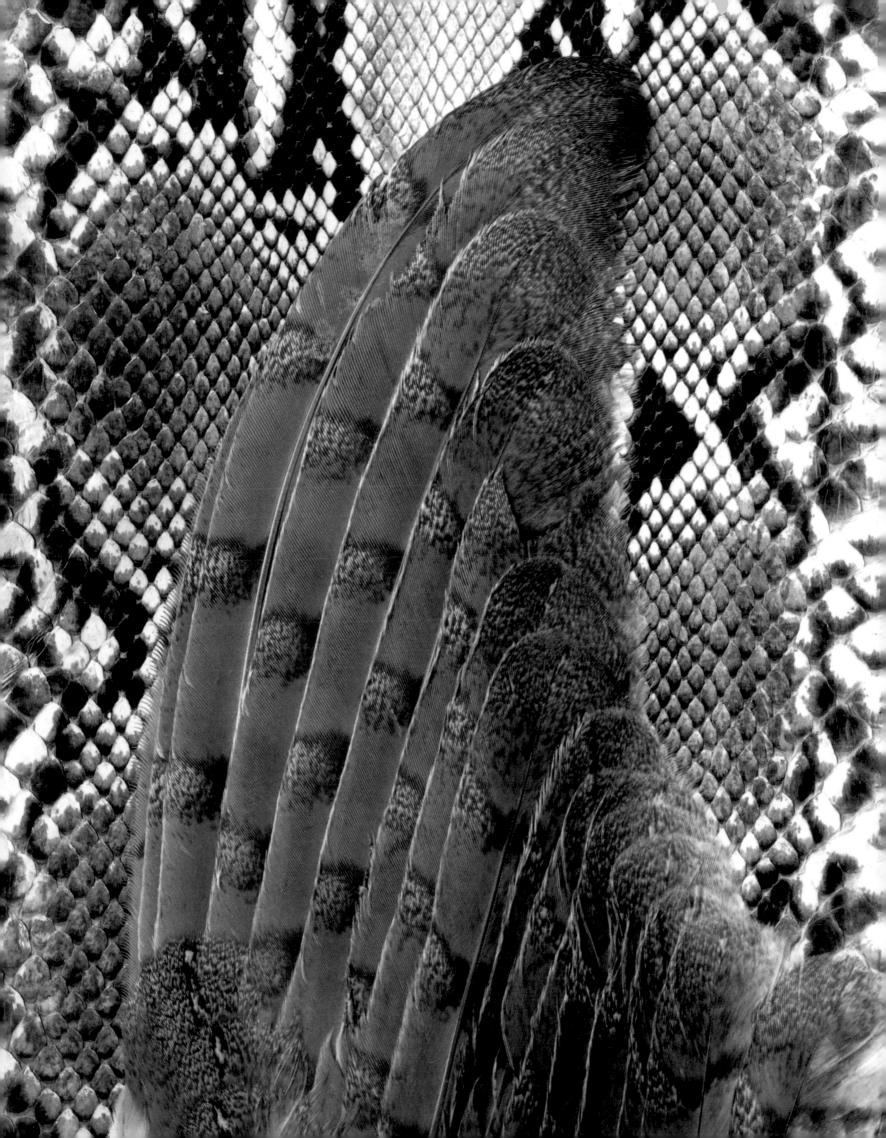

Frog and Onions 1995

Creeping 1995

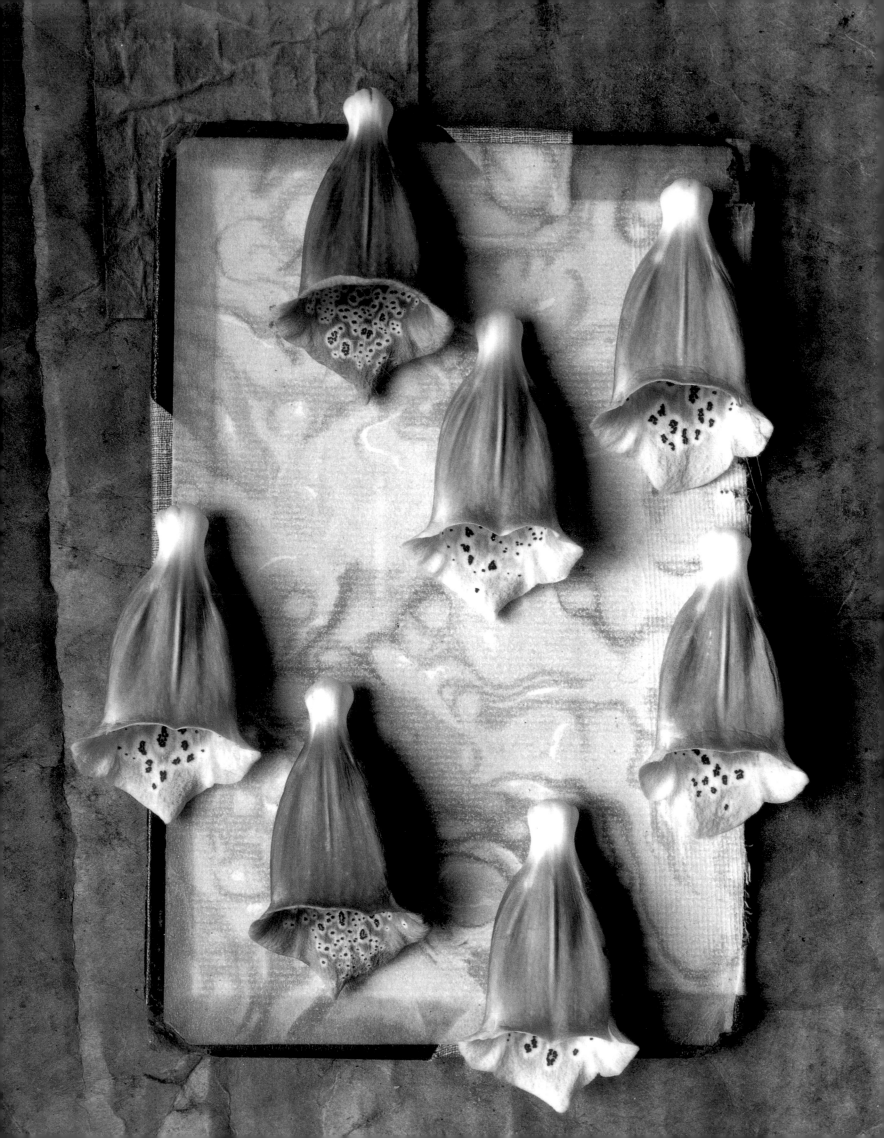

Seven Blossoms 1995

Eyes on Paper 1990
Cormorant 1990
After the Rain 1995

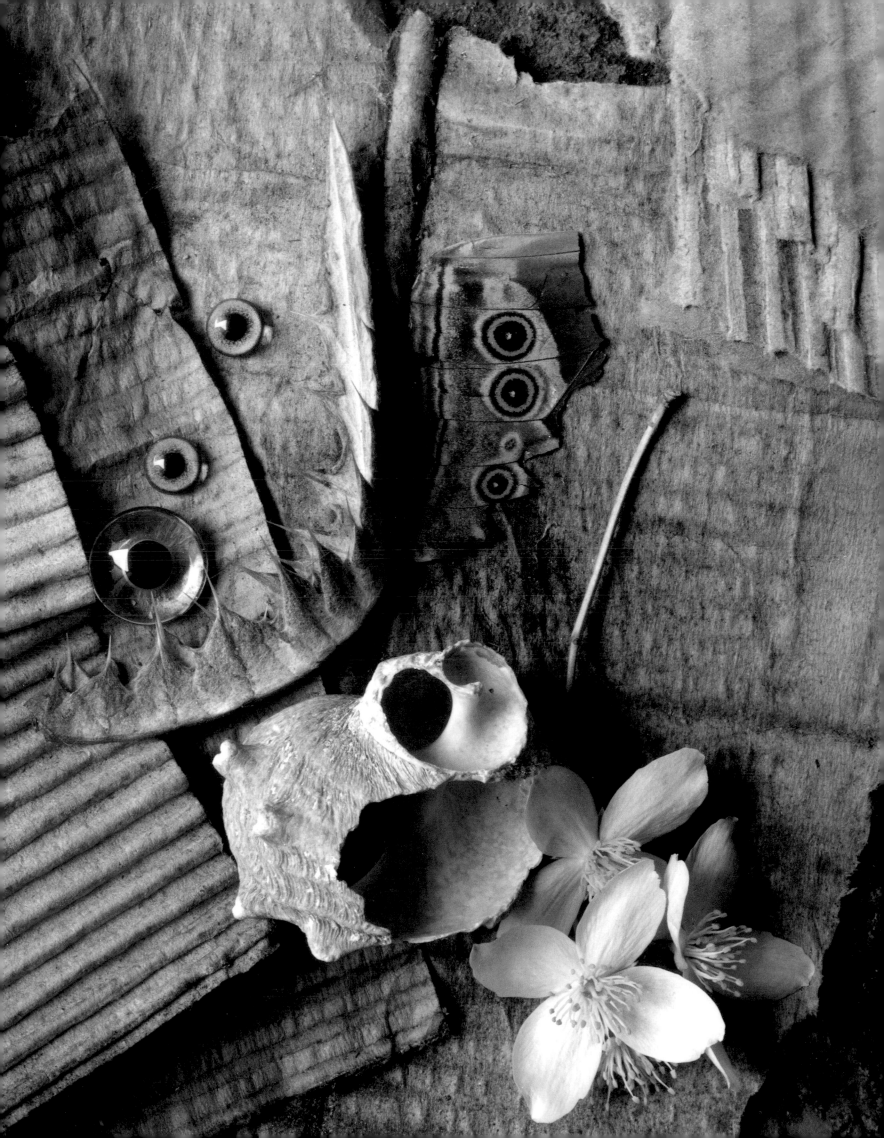

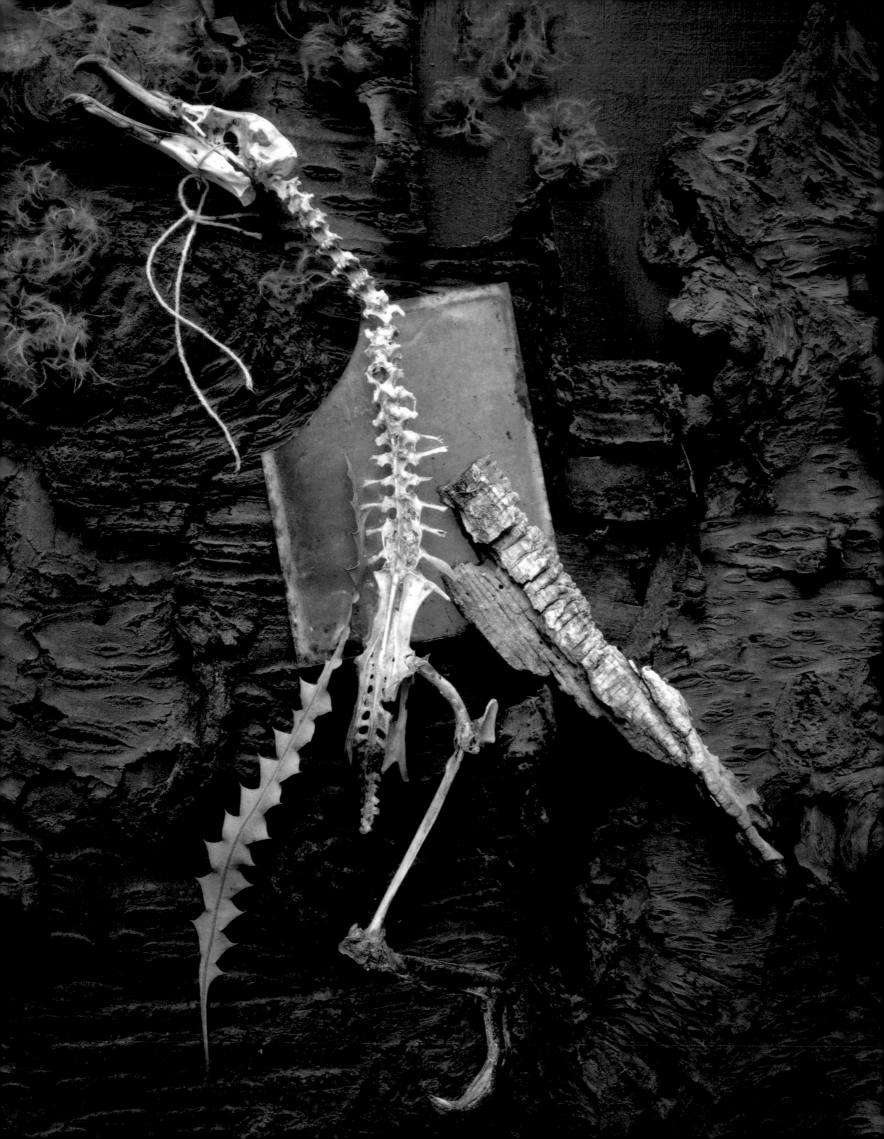

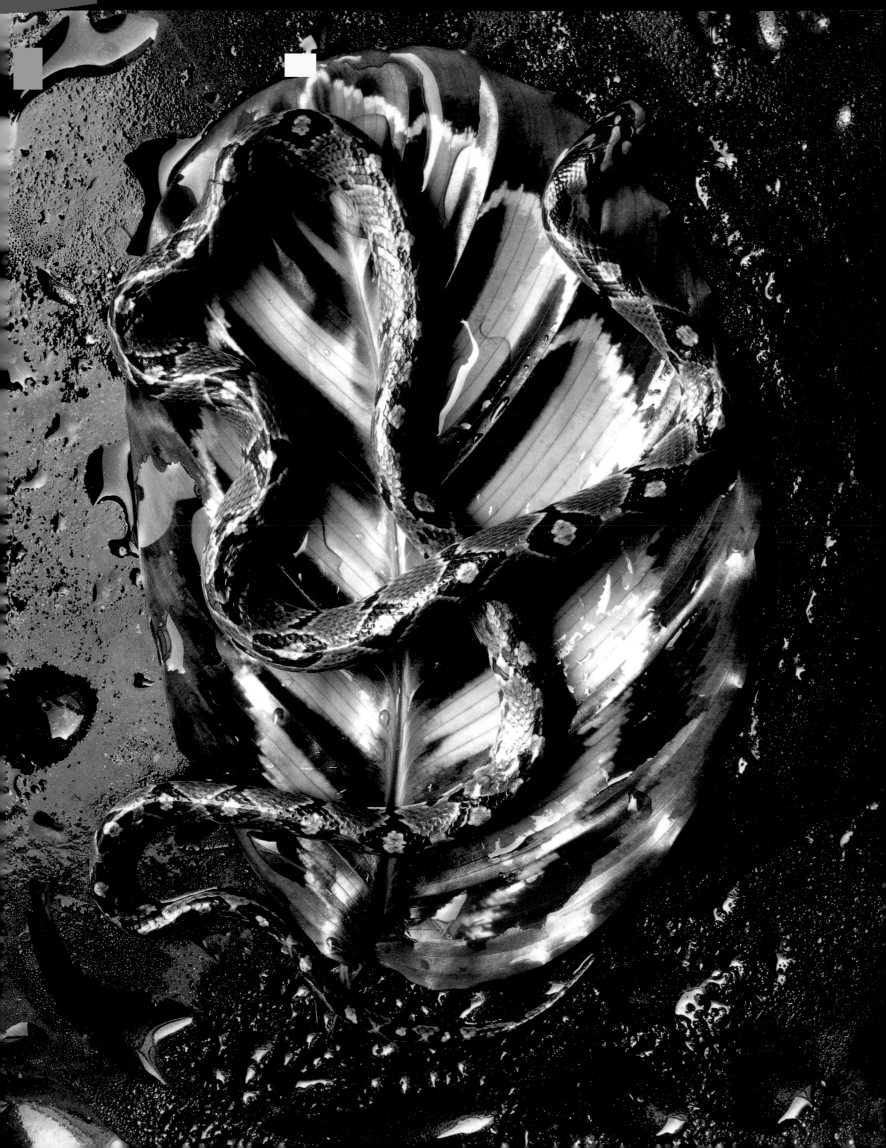

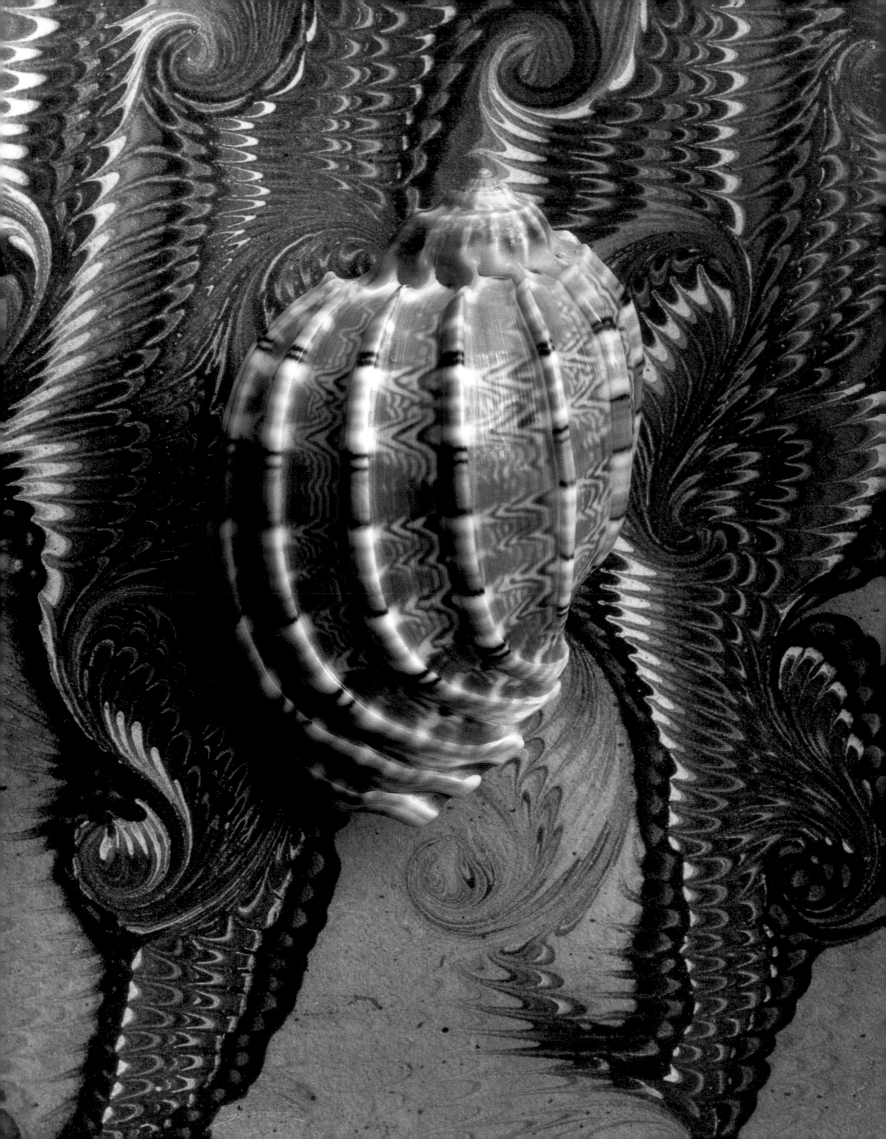

Camouflage of a Shell 1995

Moonlight Shells 1994

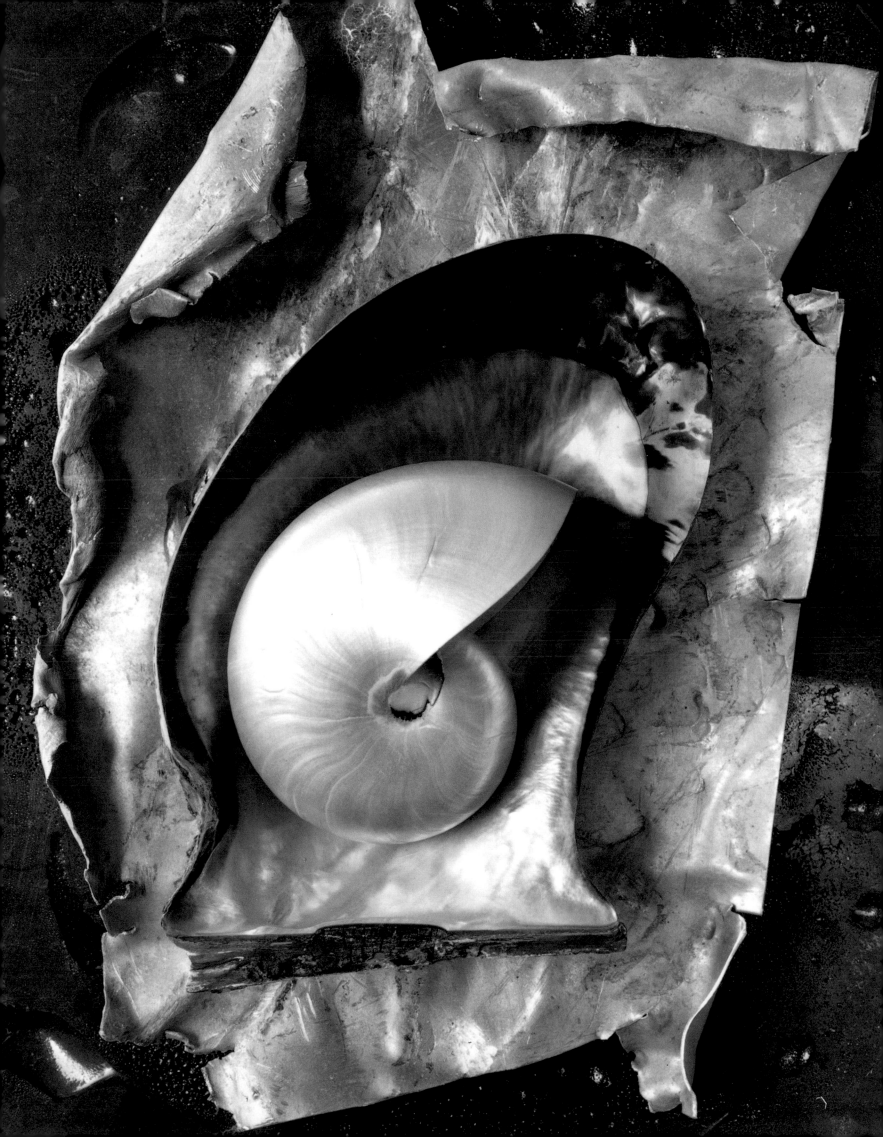

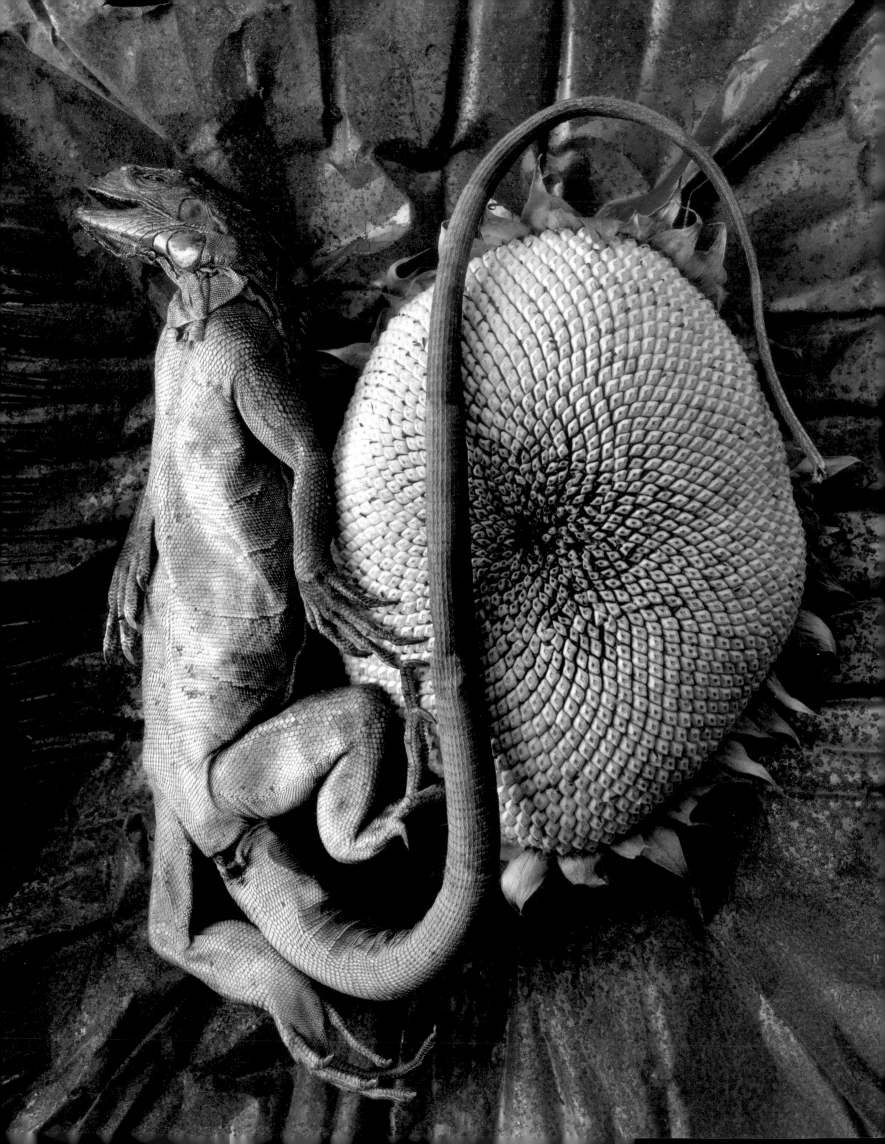

Iguana and Sunflower 1989

Flower and Beast 1991

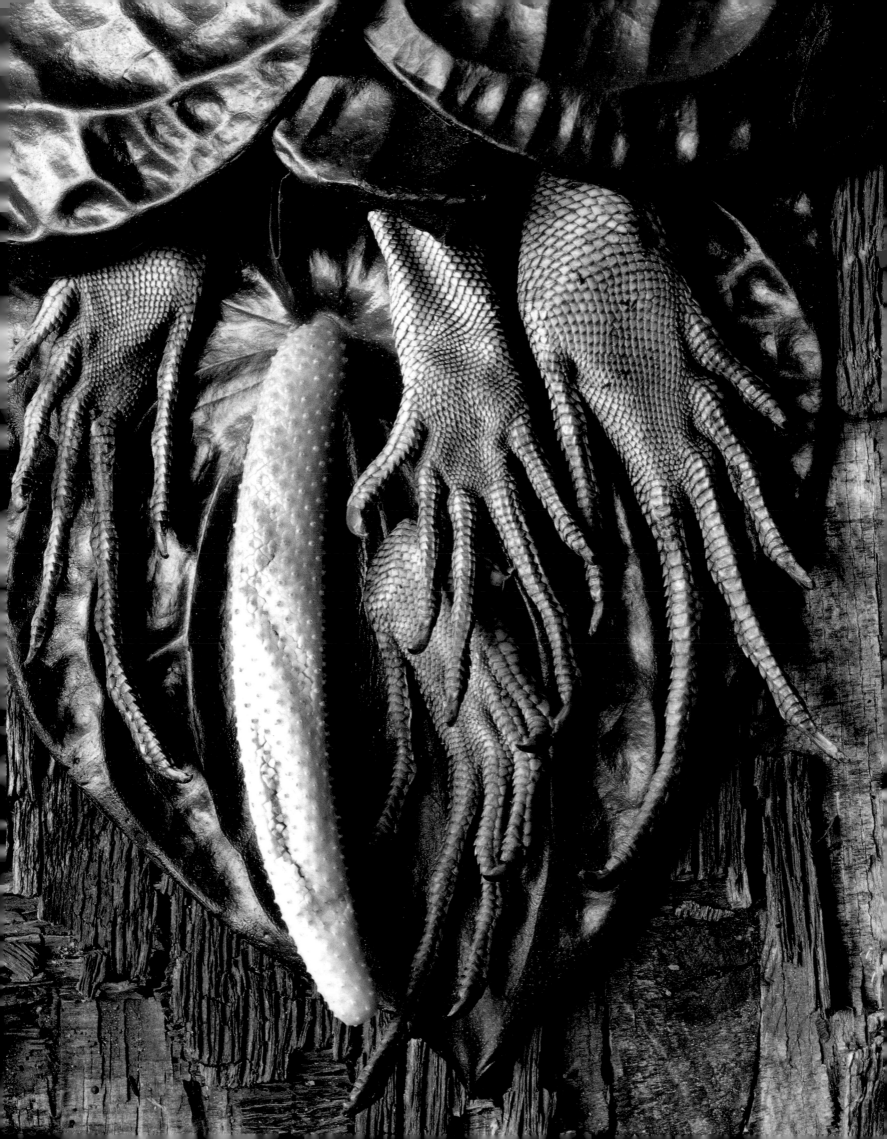

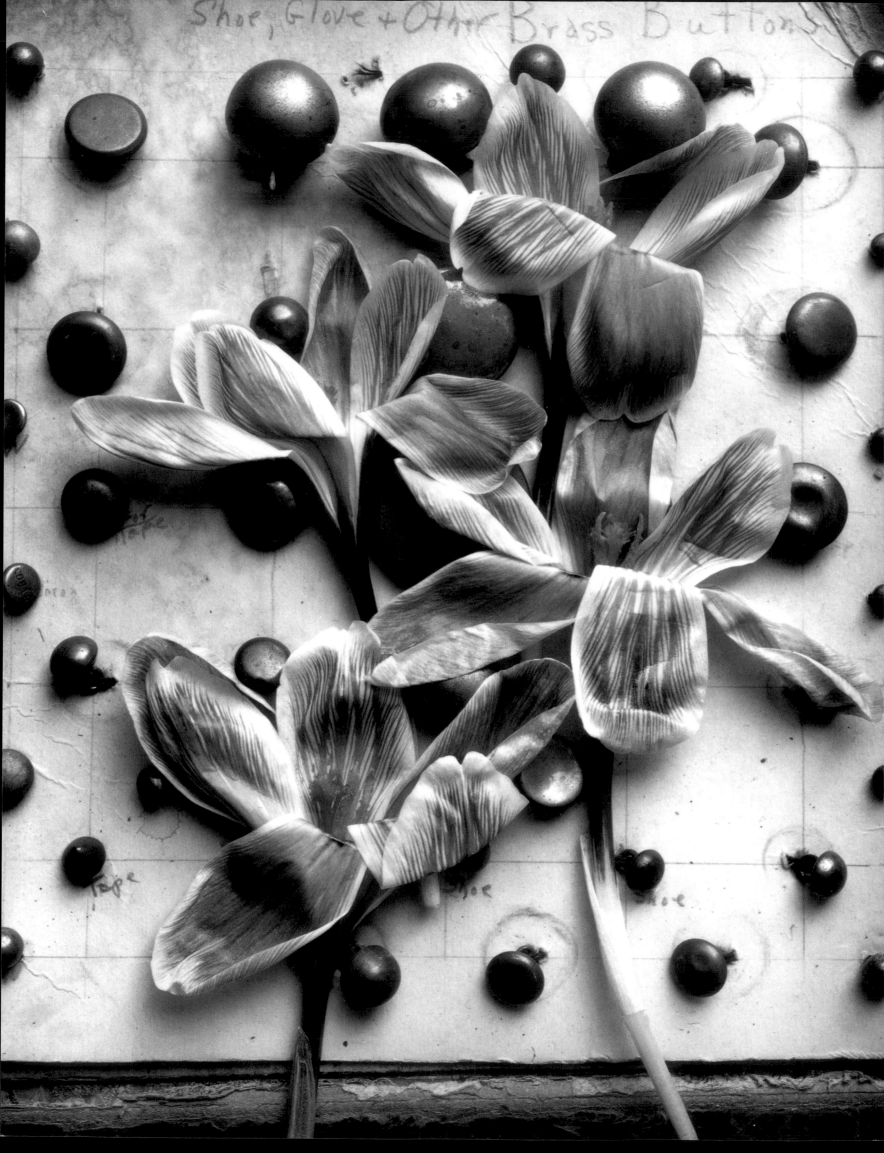

Crocus and Buttons 1995

Oyster 1995
Wing of a Seagull 1995
Coquilles Saint Jacques 1995

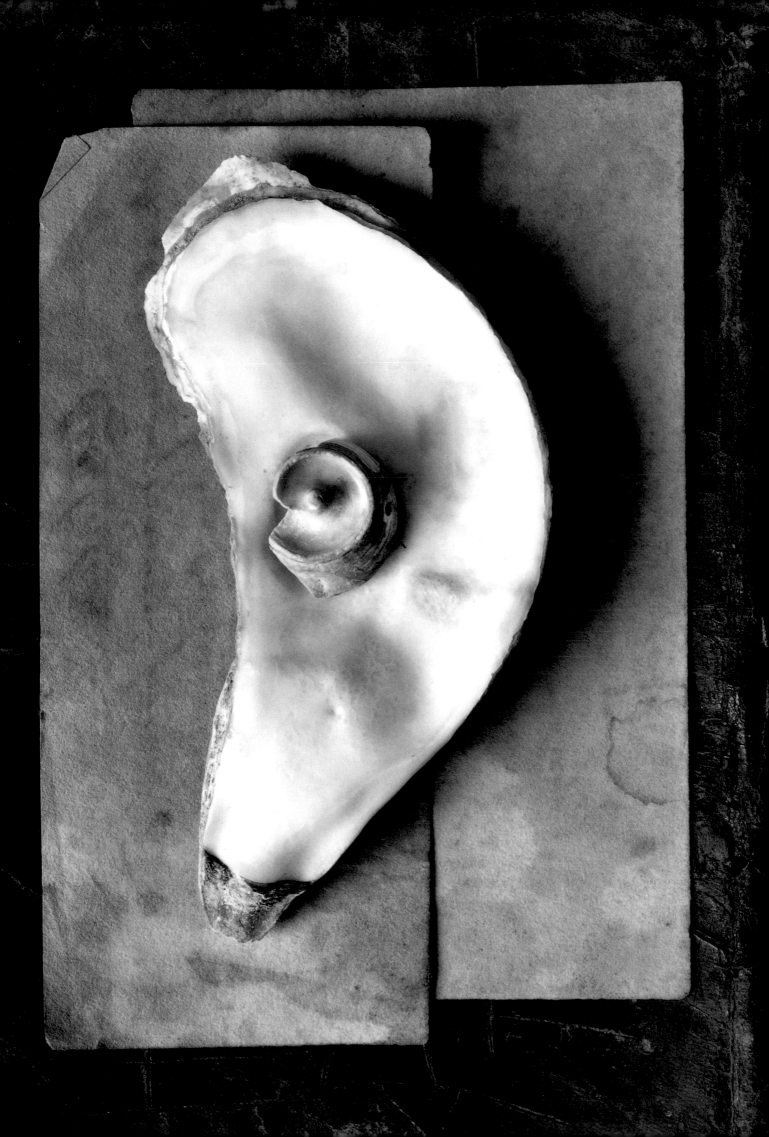

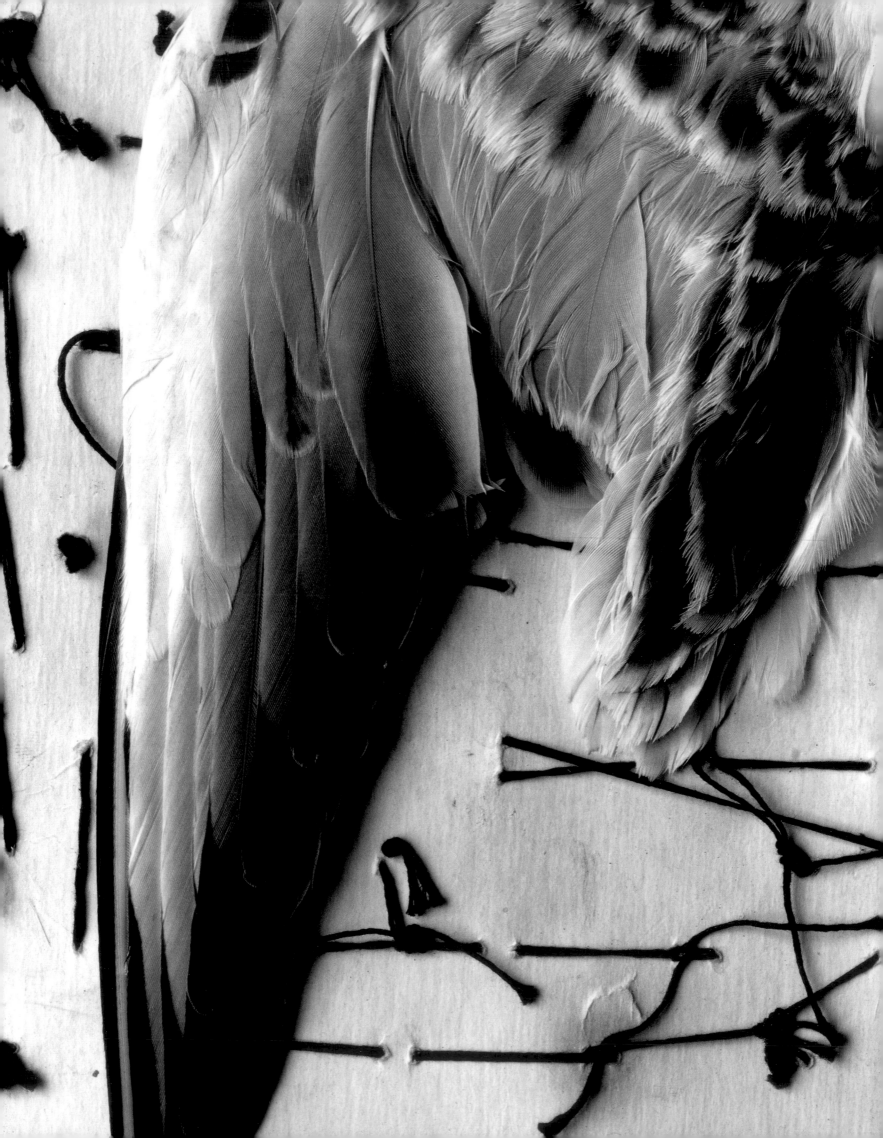

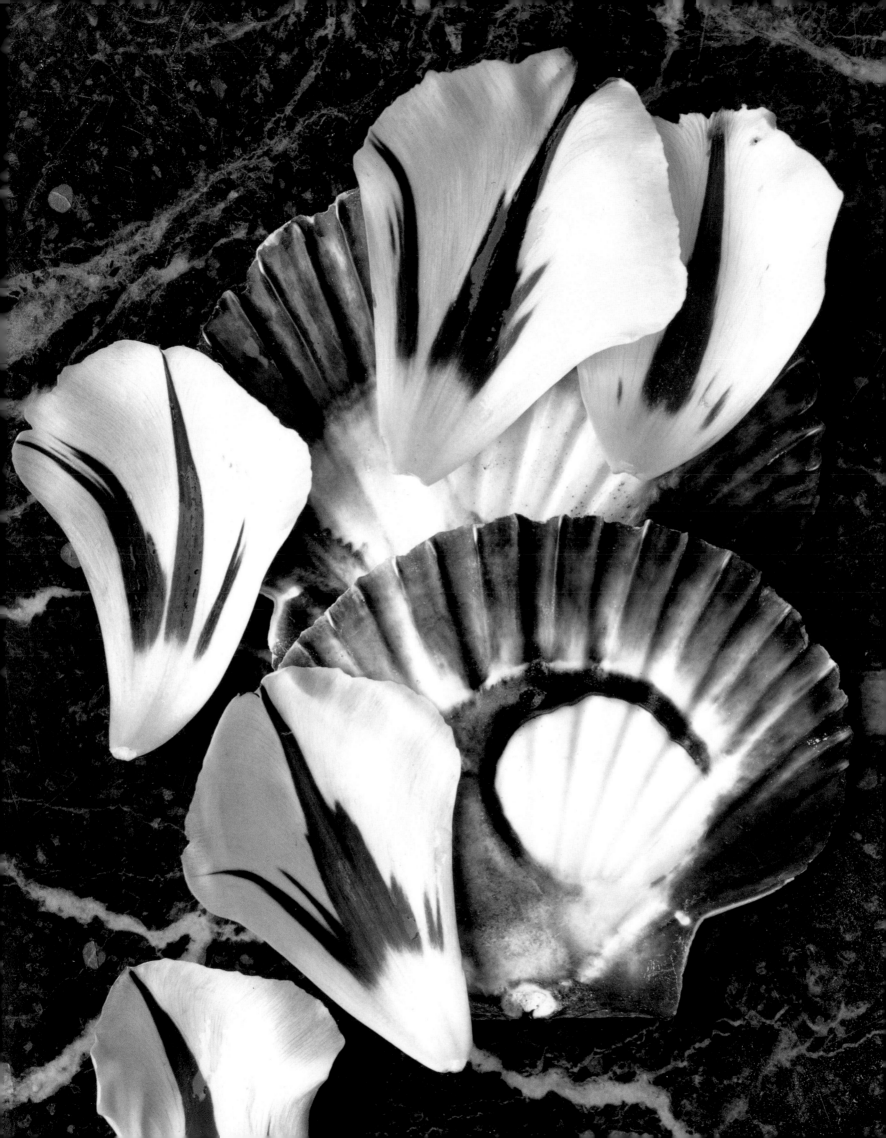

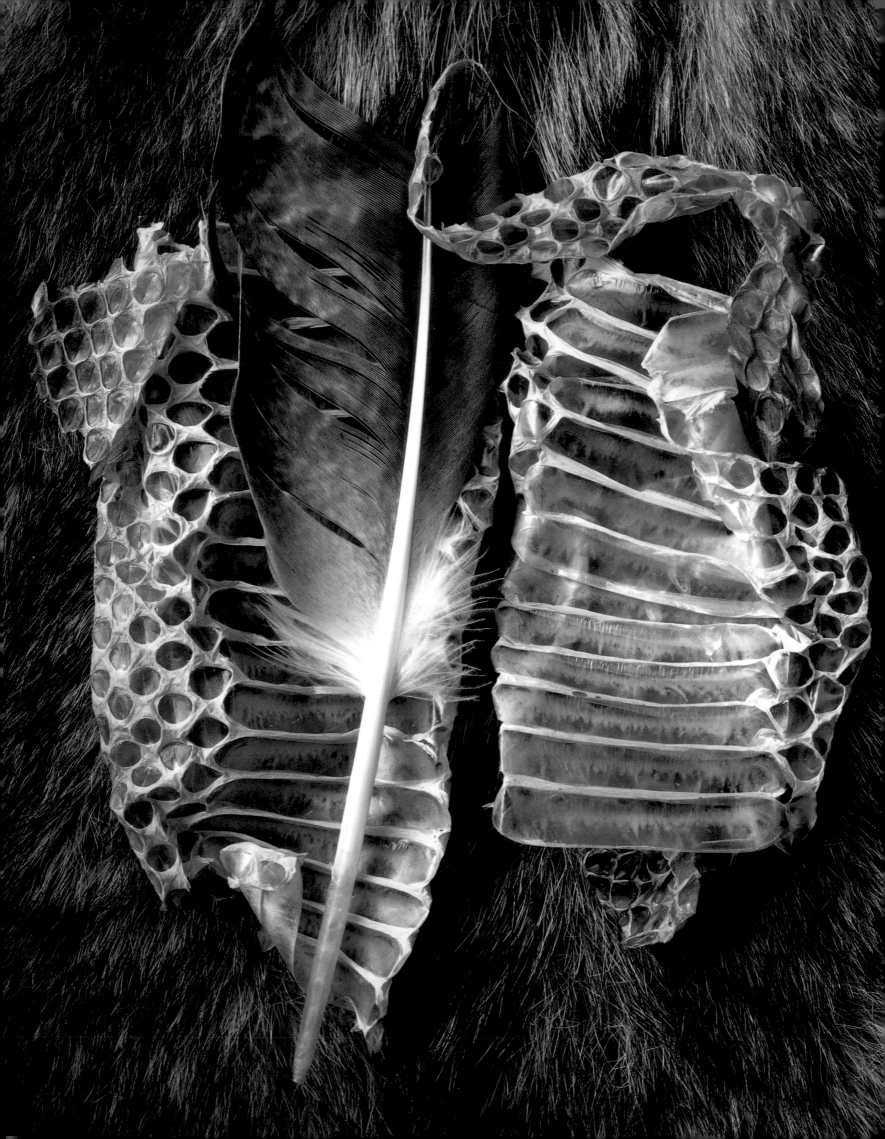

Snake Skin with Feather 1995

Snake and Shells 1990

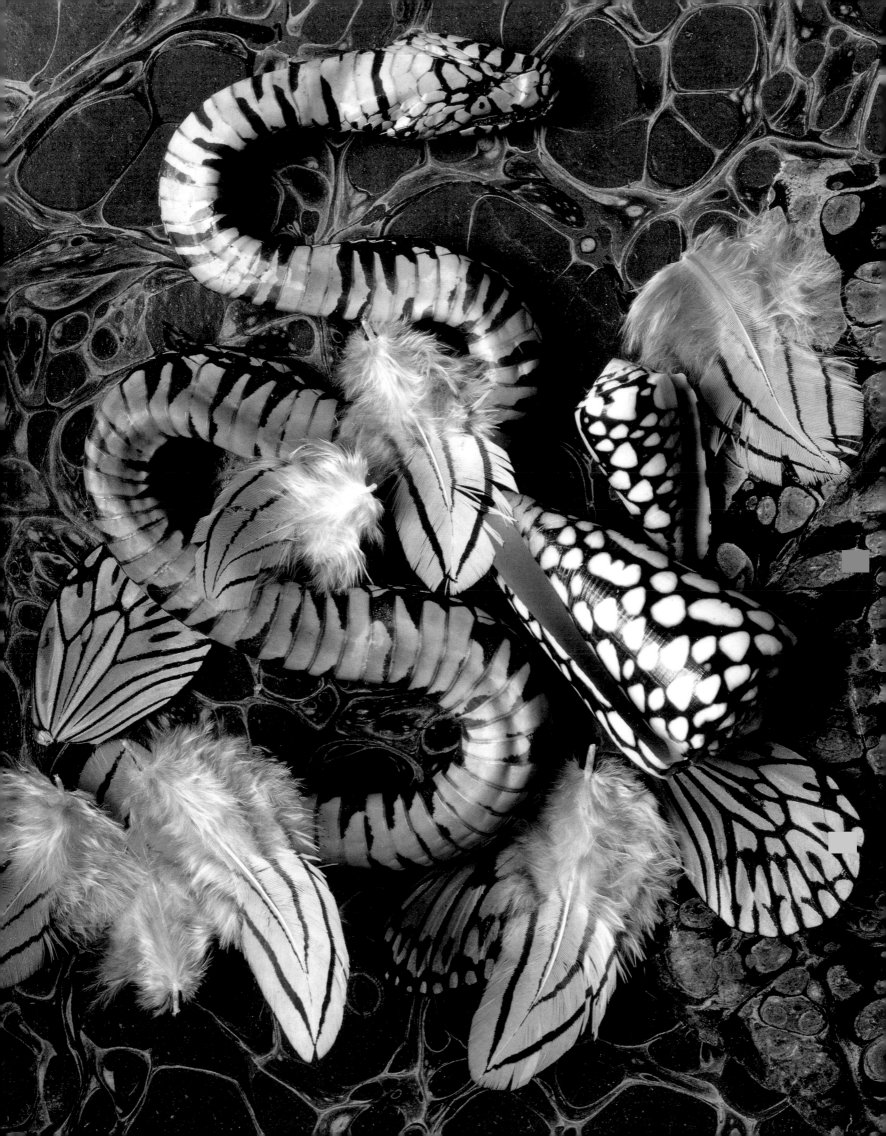

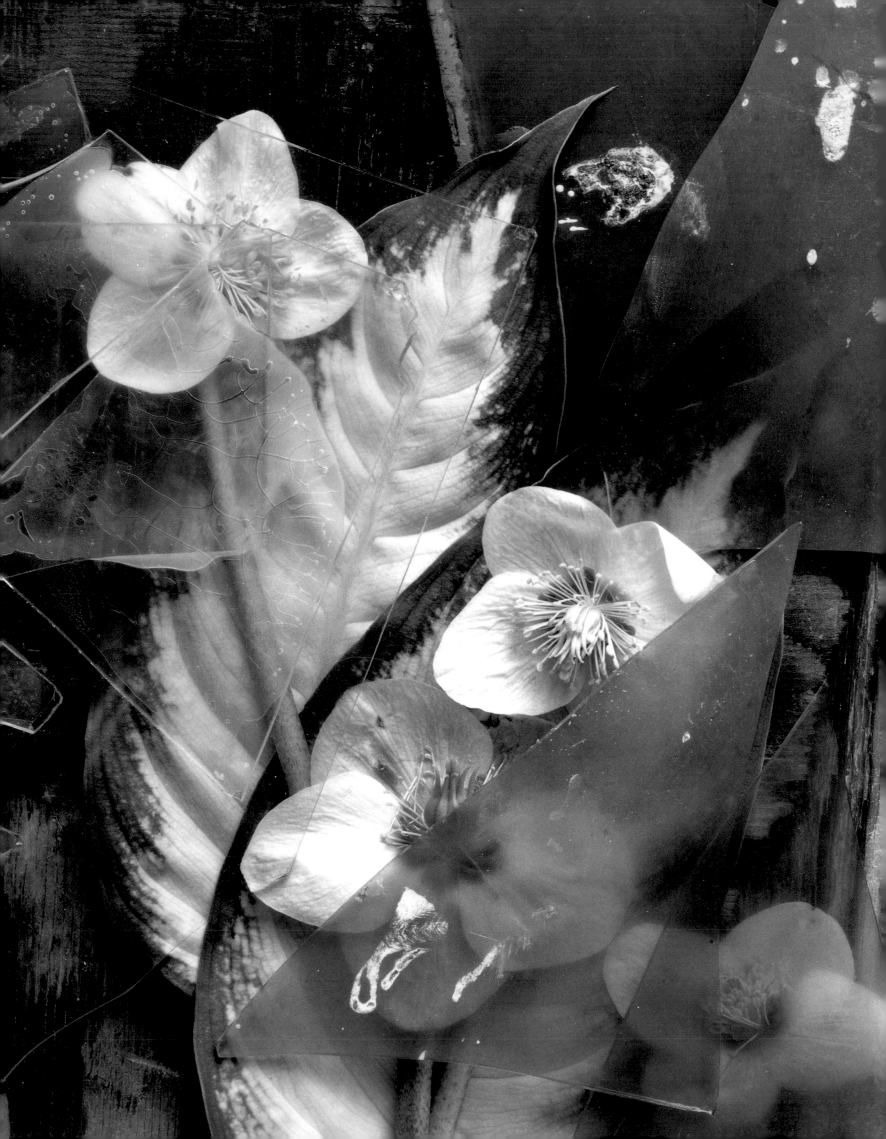

Broken Glass and Flowers 1993

Three Pieces 1989

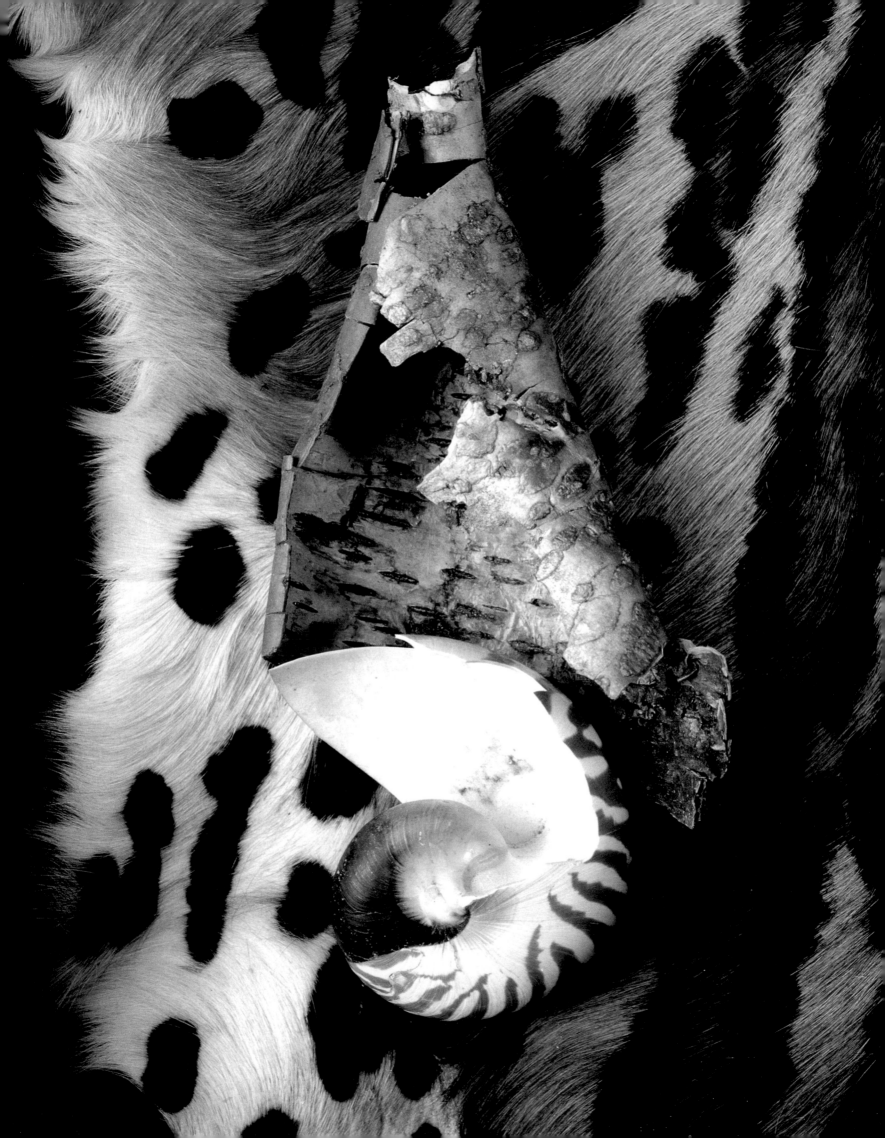

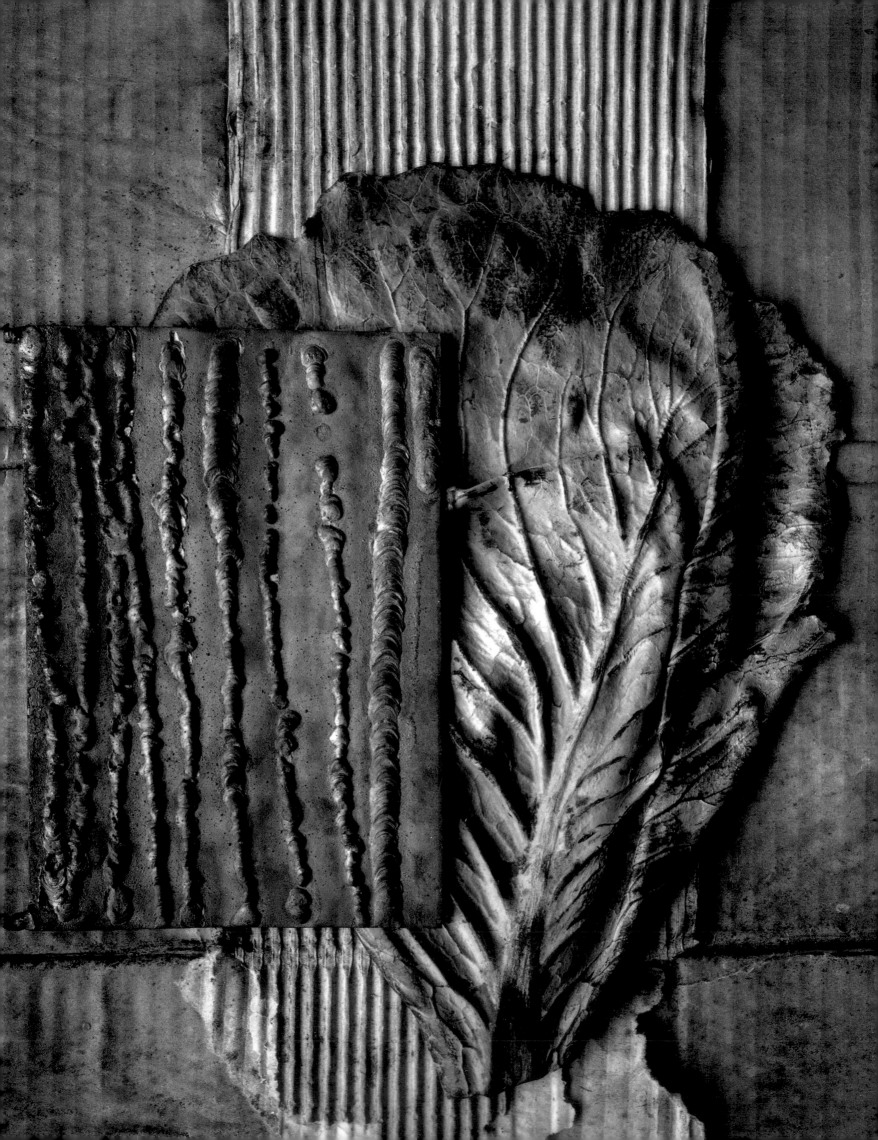

Cabbage Leaf 1992

Chinese Drawing 1992
Abalone 1995
Creeping Pearls 1995

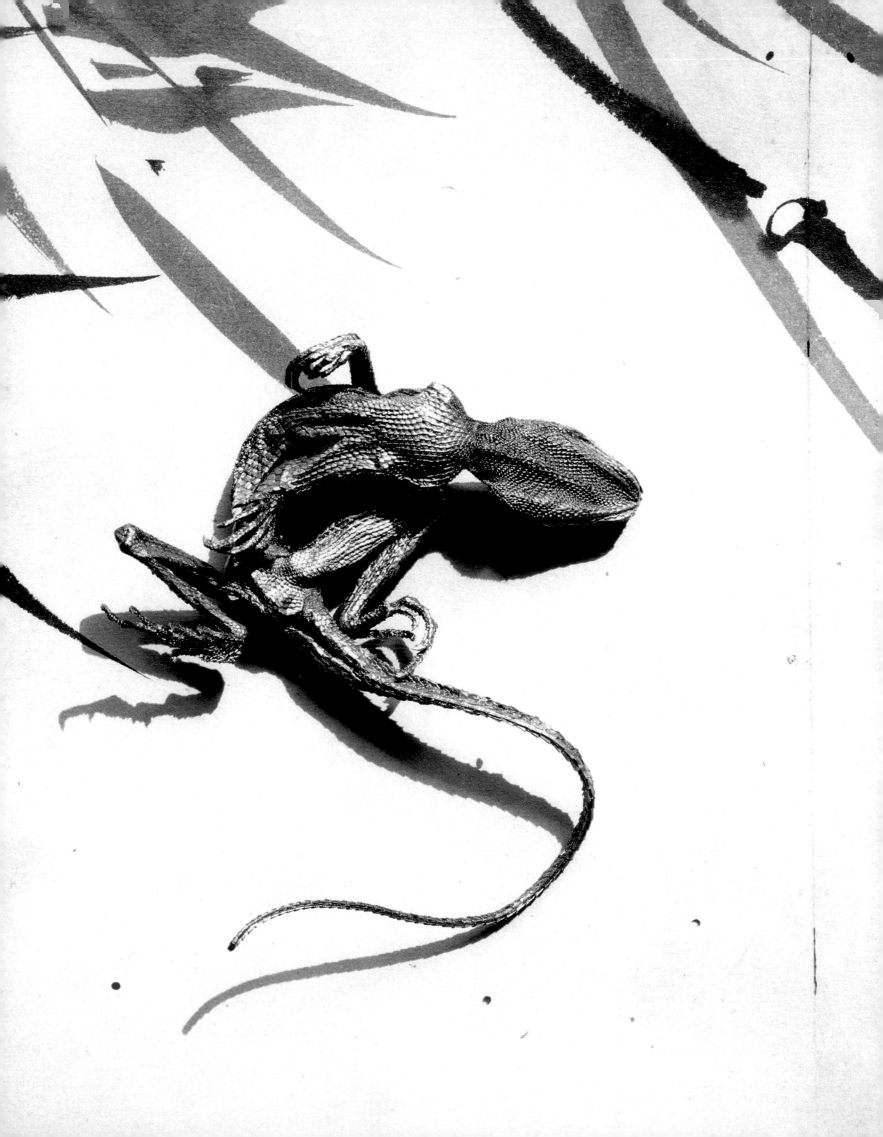

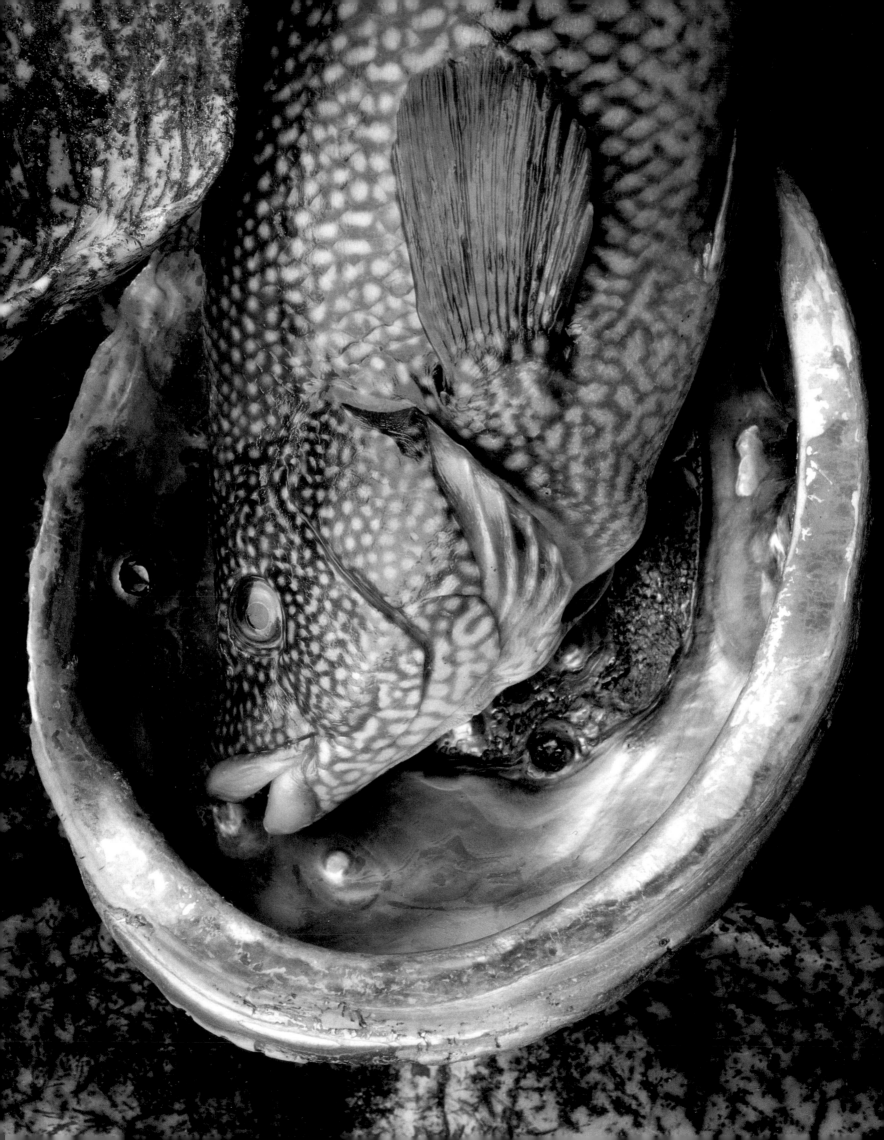

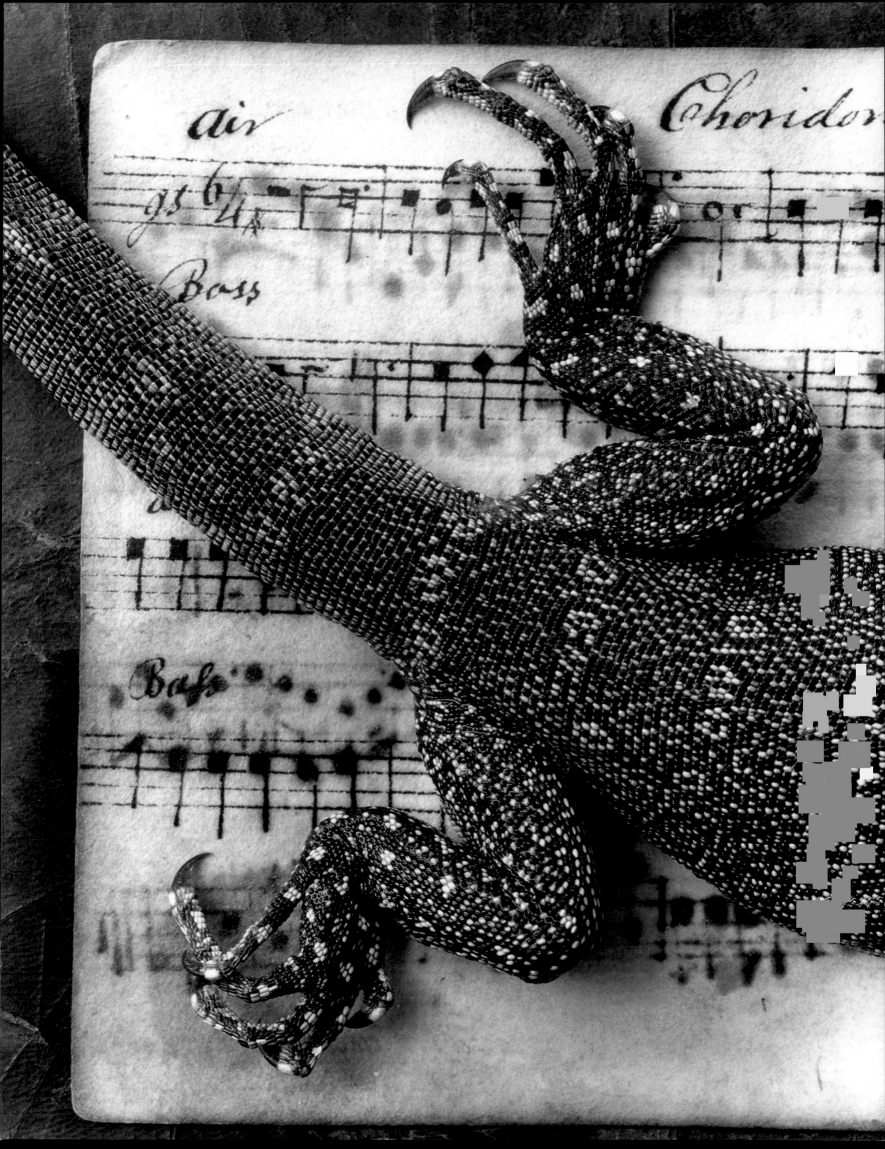

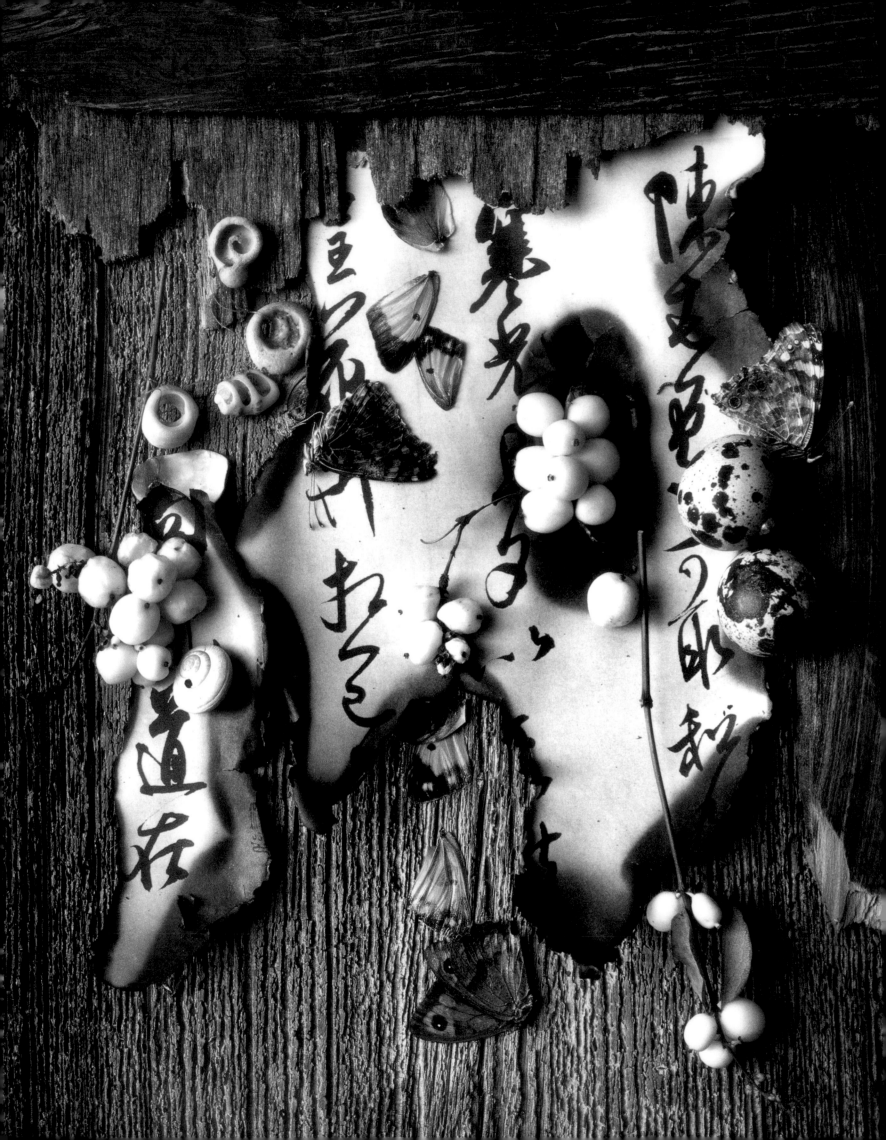

Shinkokinwakashu 1989

Deep Sea Eyes 1995

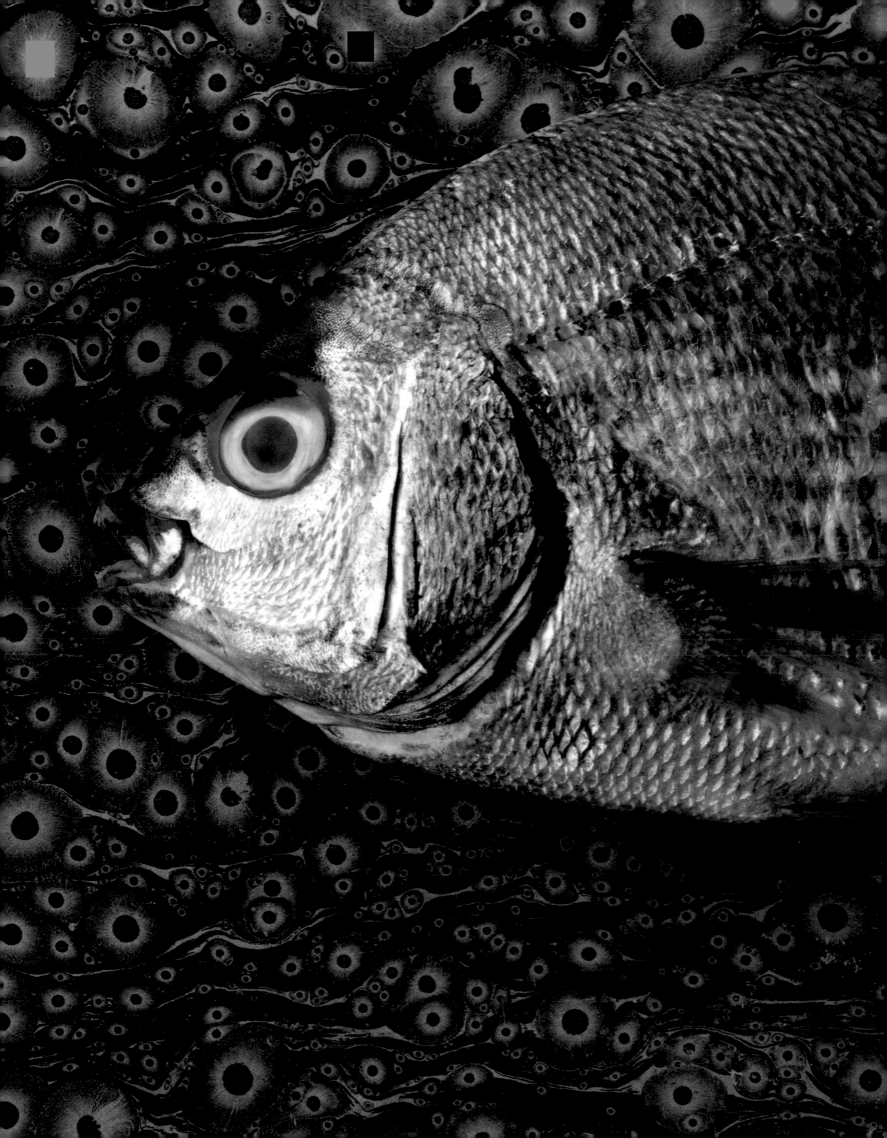

Tips and Stripes 1995

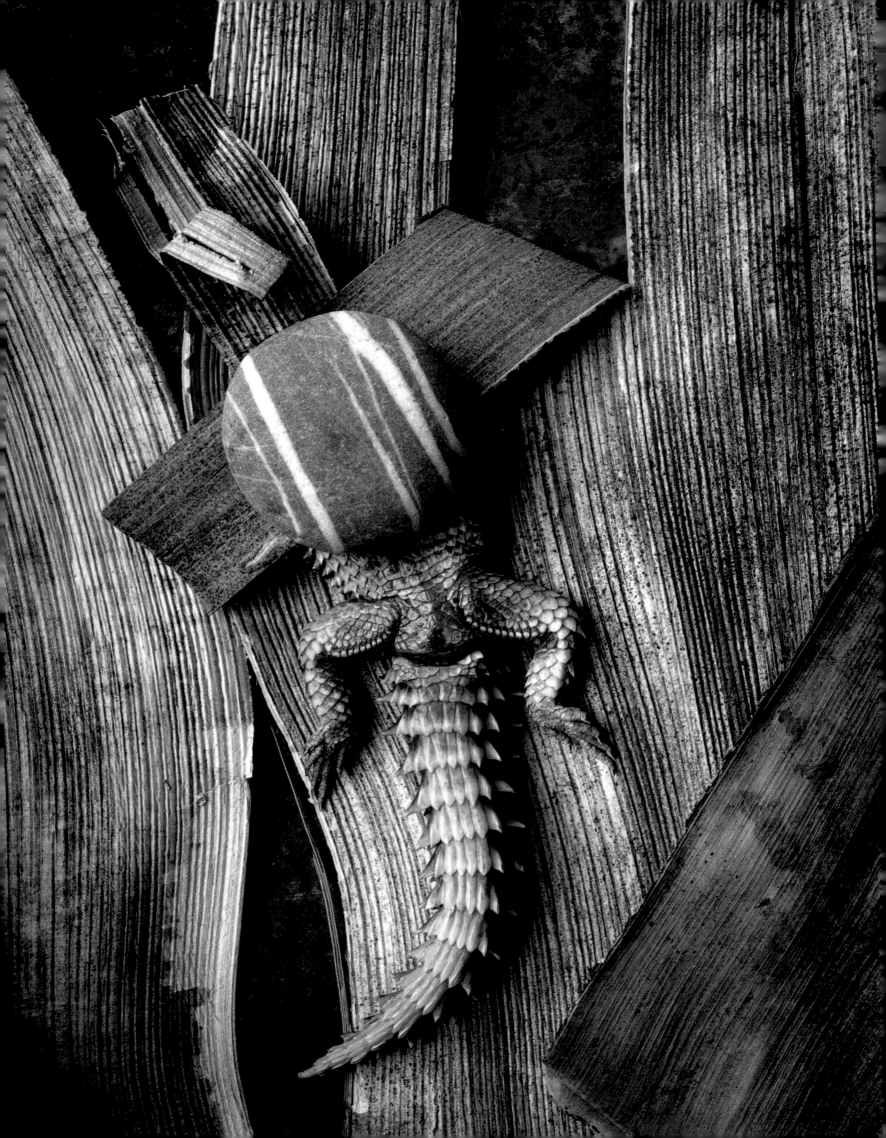

Blossoms and Garlic 1990

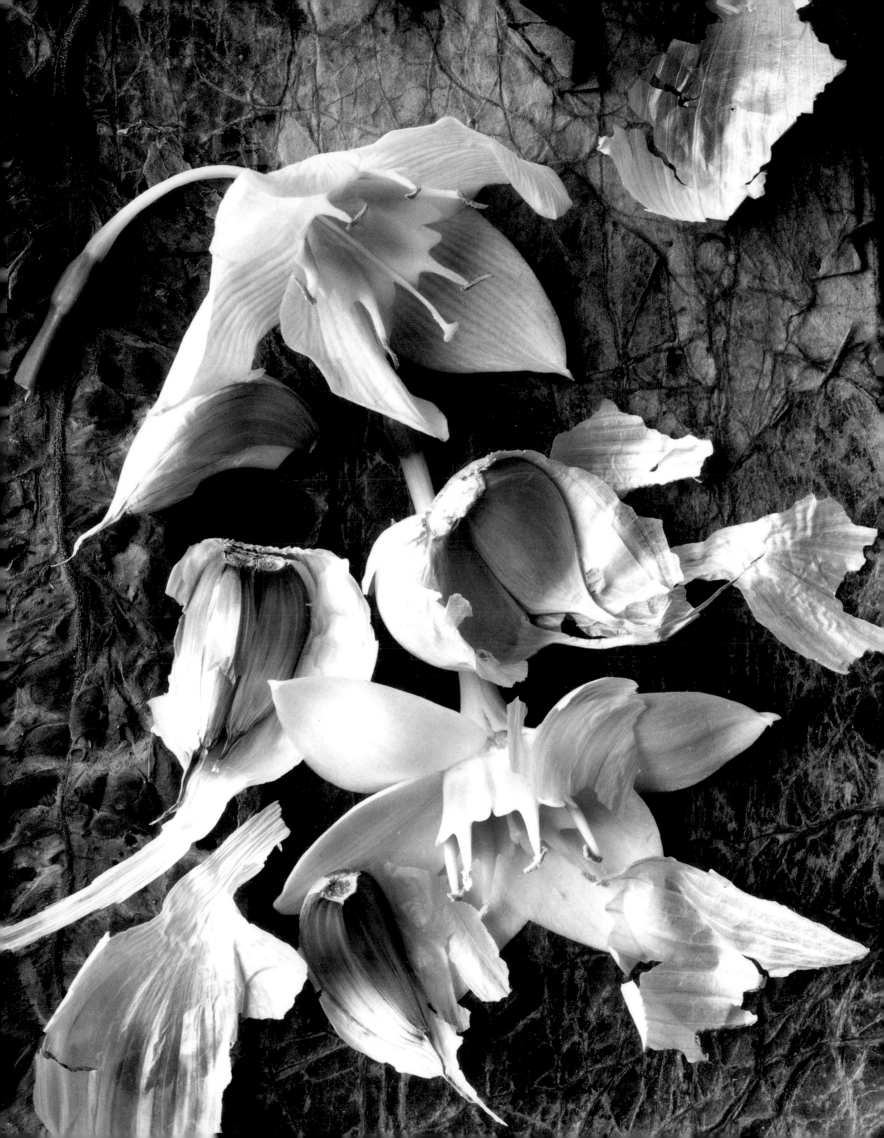

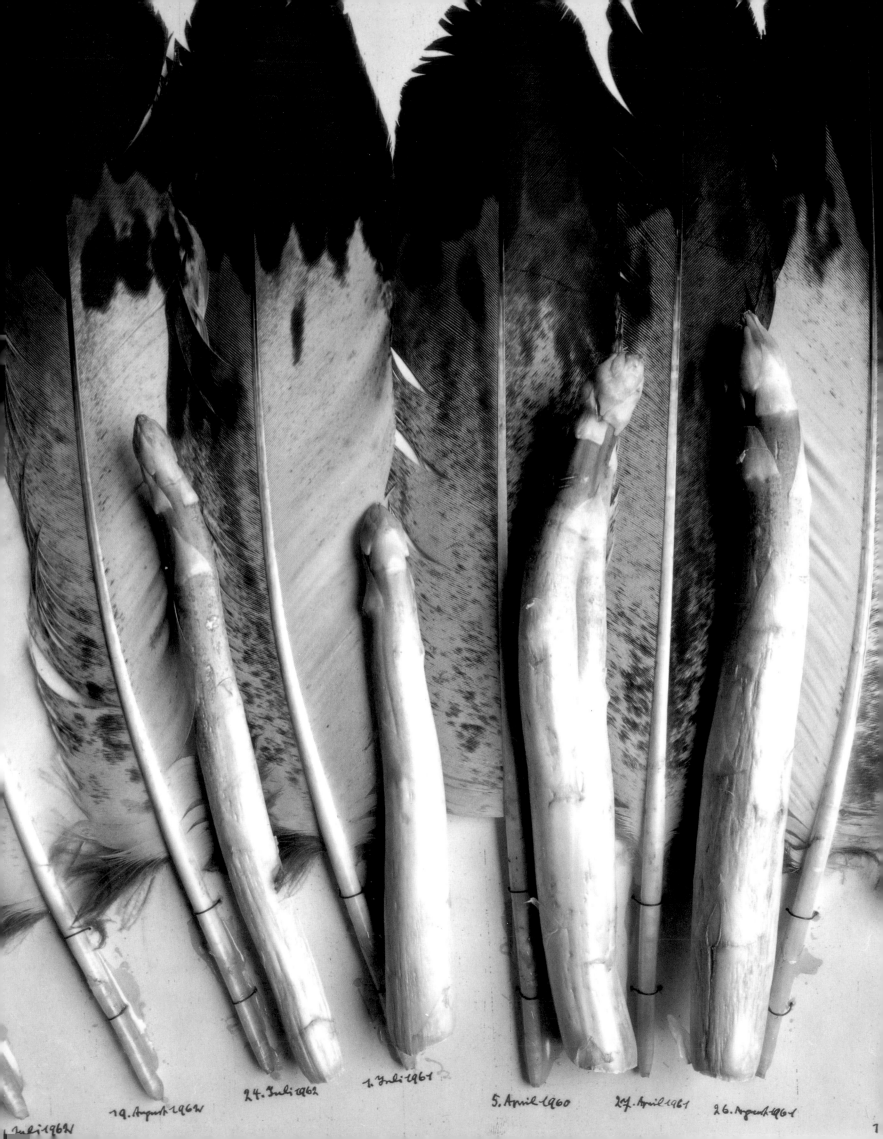

Juli 1962 19. August 1962 24. Juli 1962 1. Juli 1961 5. April 1960 27. April 1961 26. August 1961

Eagle Feathers 1995

Very Light Feathers 1992
Floating Characters 1995
Pair of Feathers 1994

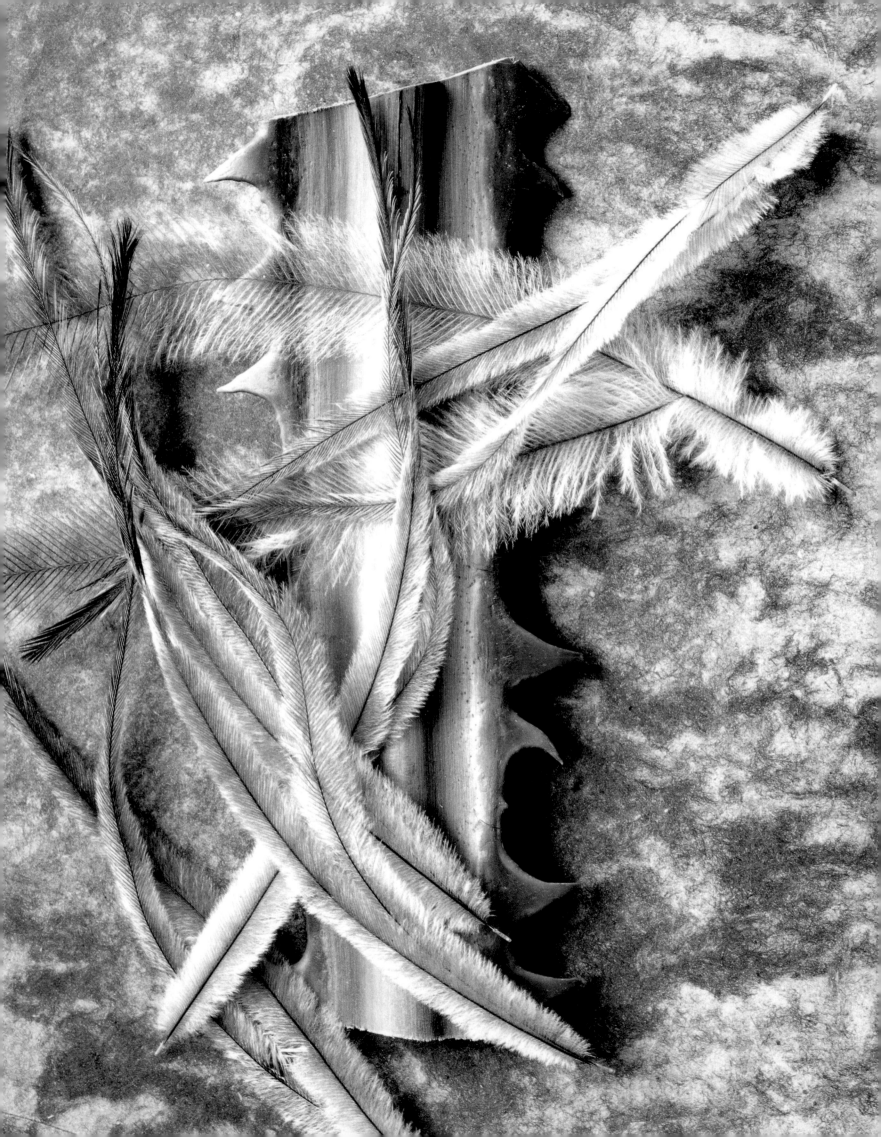

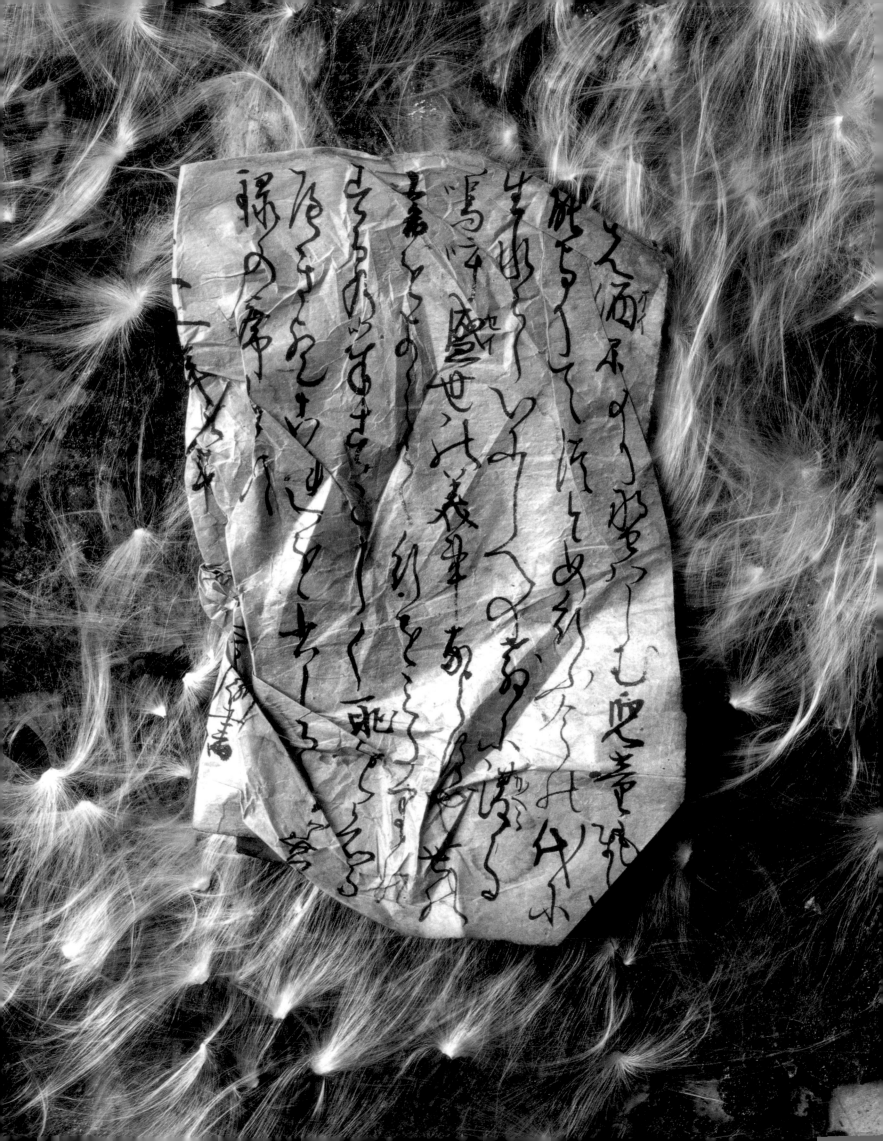

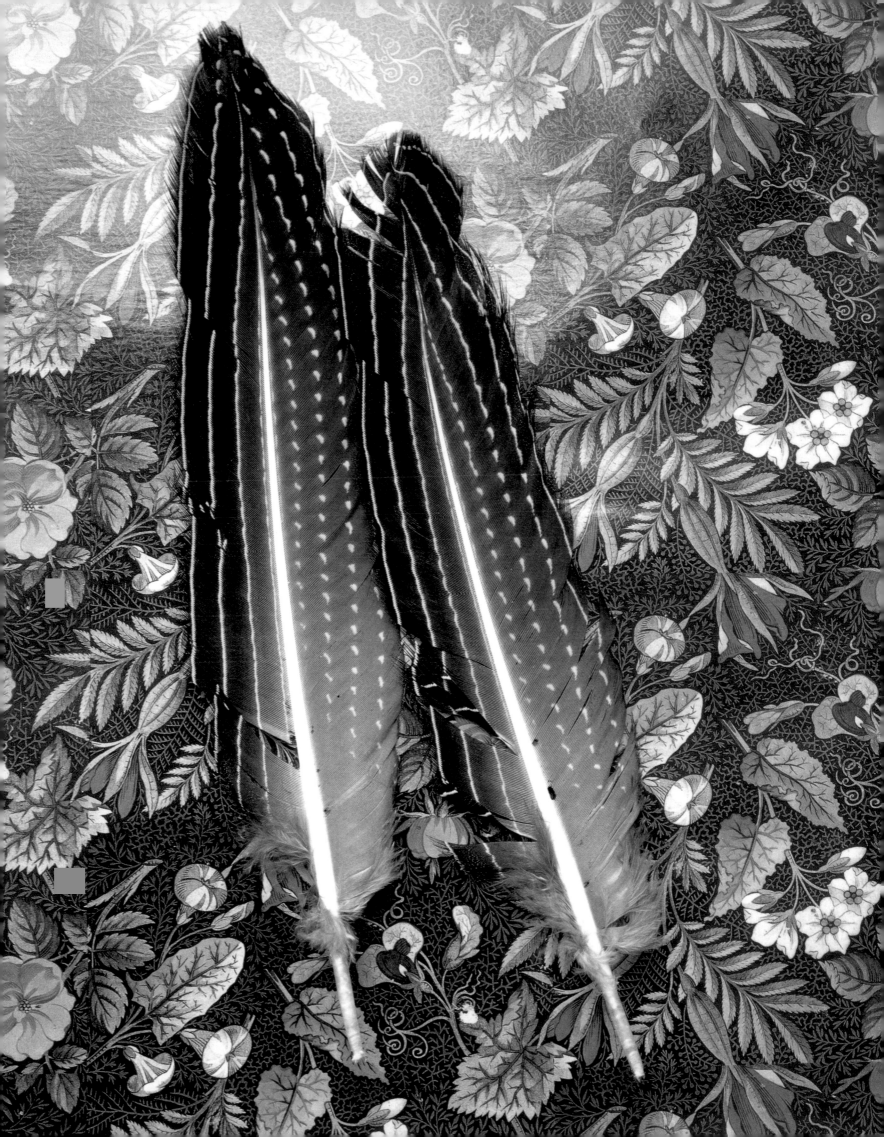

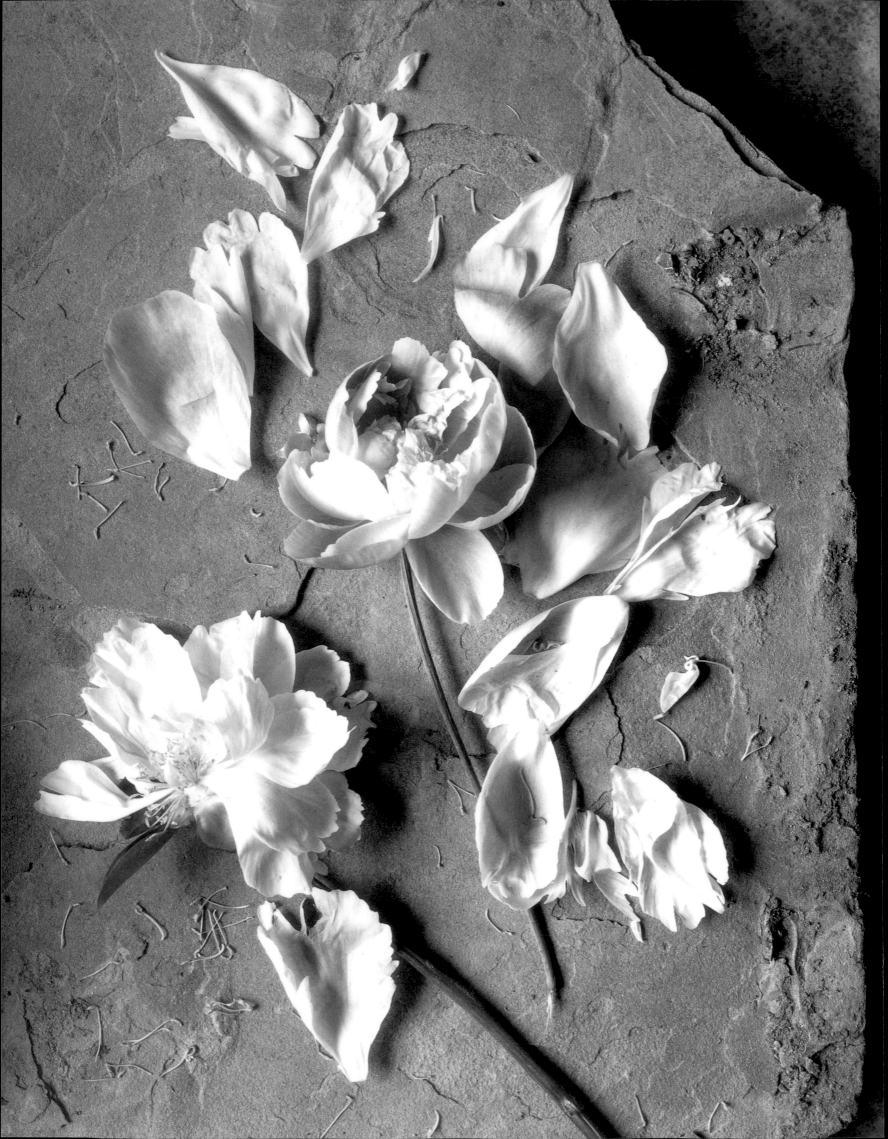

Flowers on a Stone 1994

Funeral for a Birdy 1988

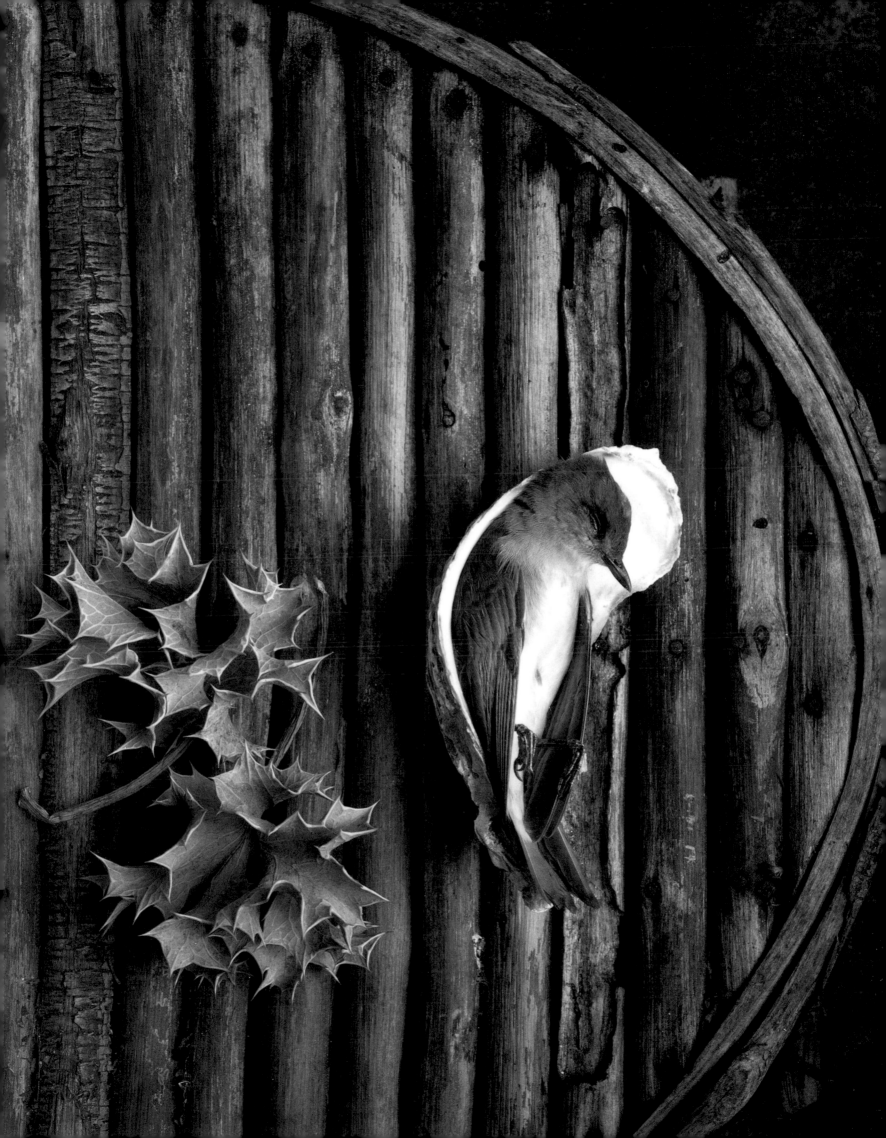

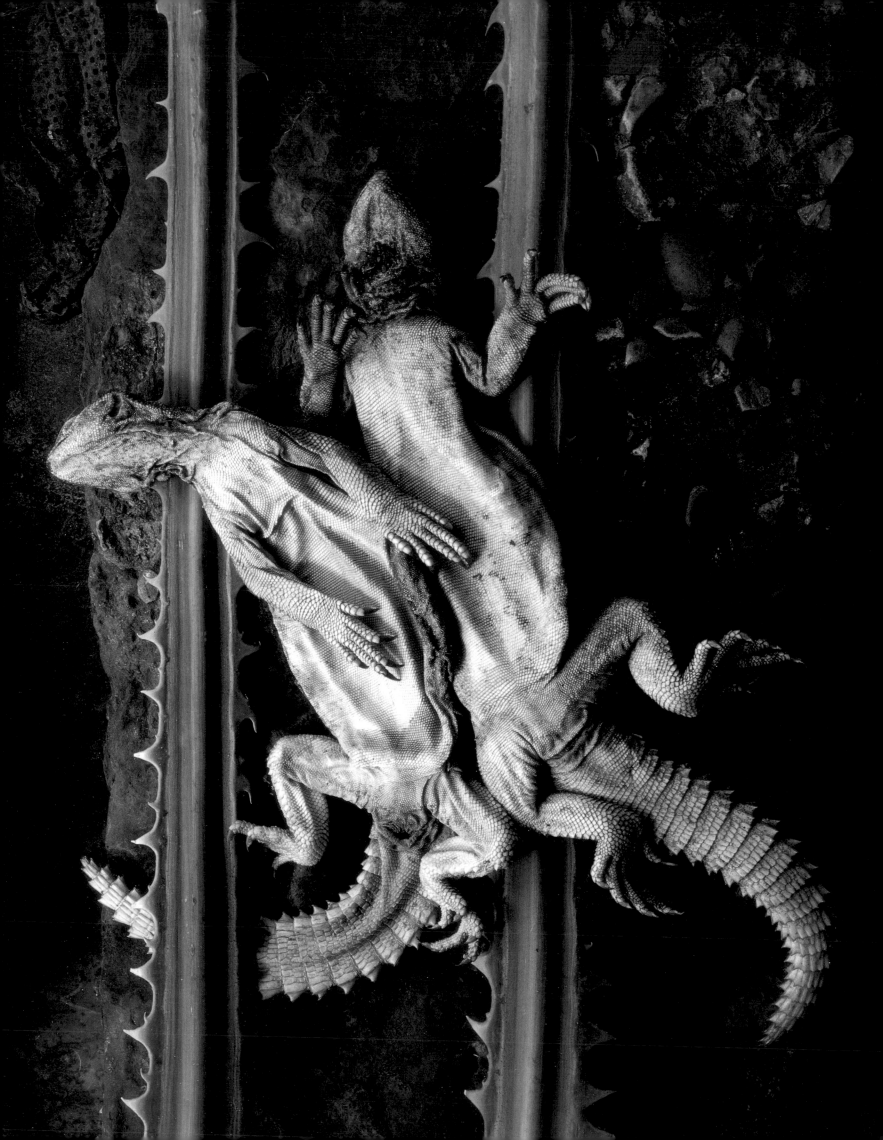

Iguana Dance 1990

Fox Fur 1989

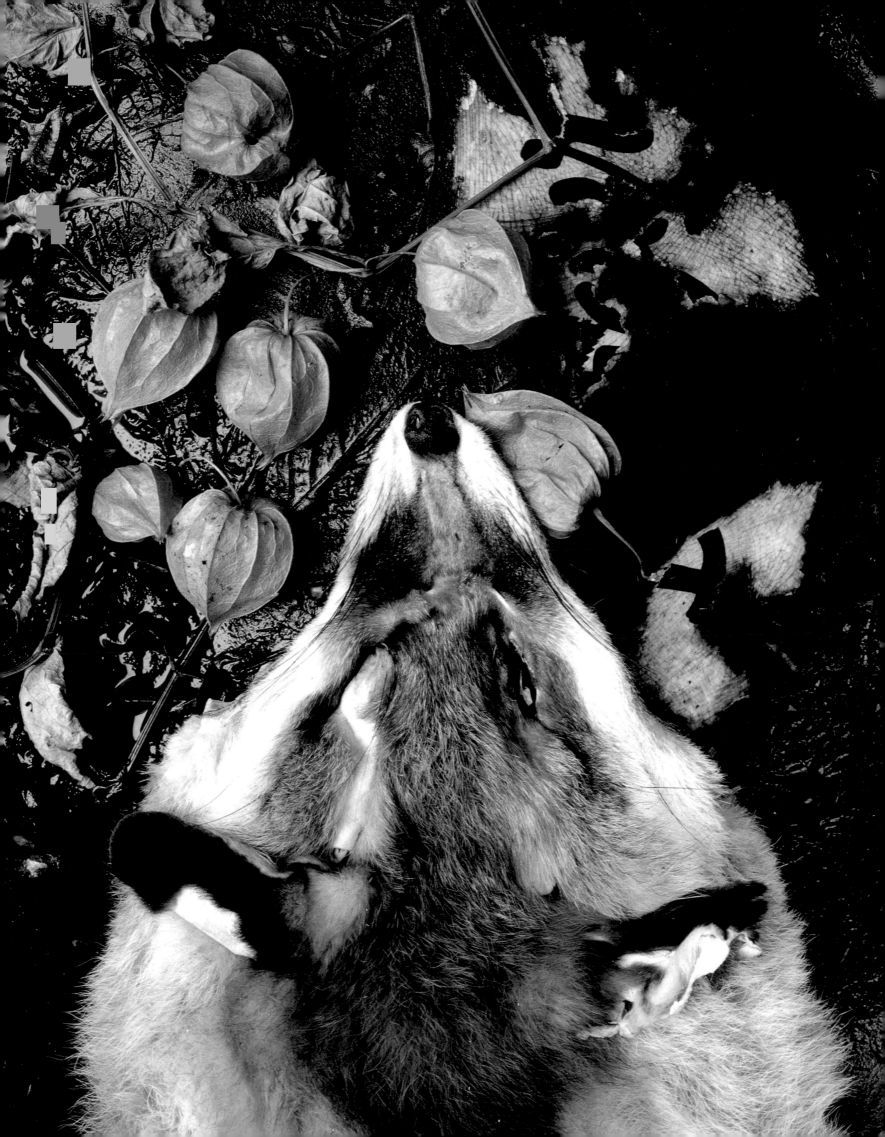

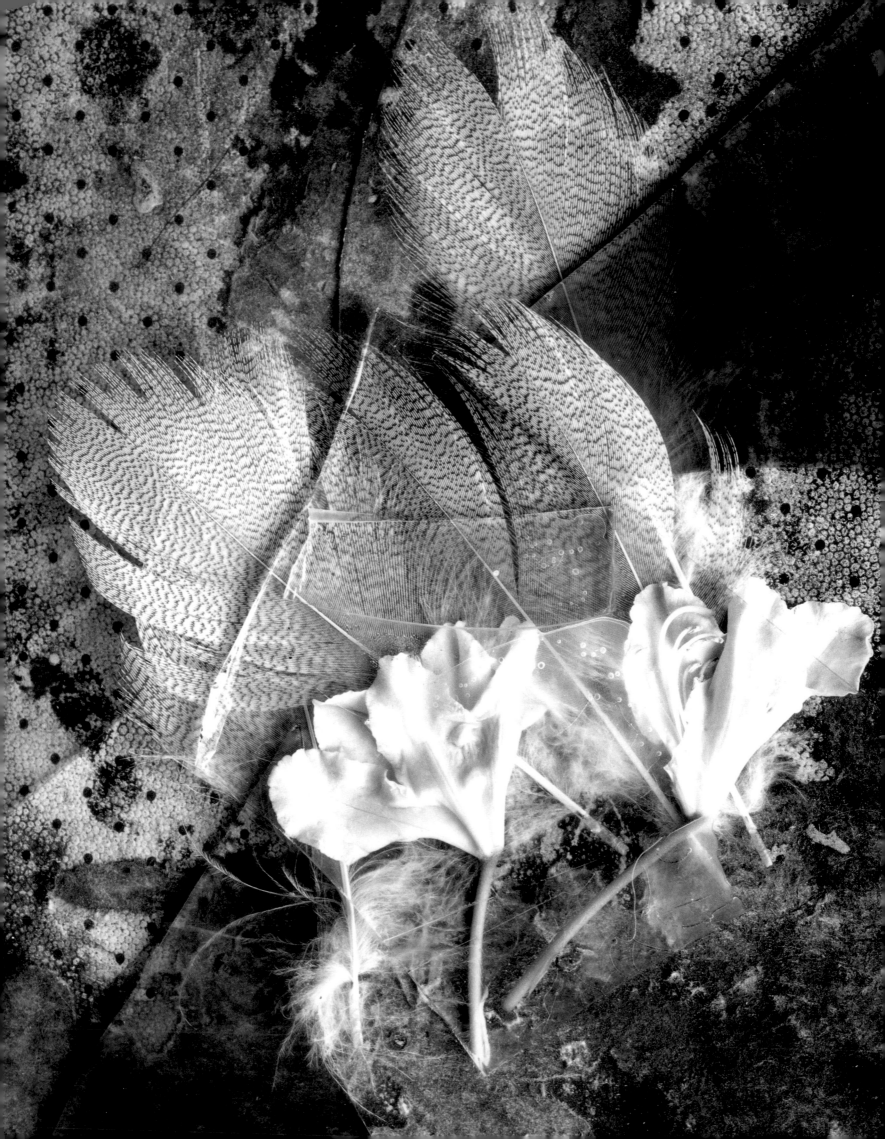

Very Light Feathers under Broken Glass 1992

The White Side of a Ray 1995
Barn Owls 1995
Broken Orchids 1992

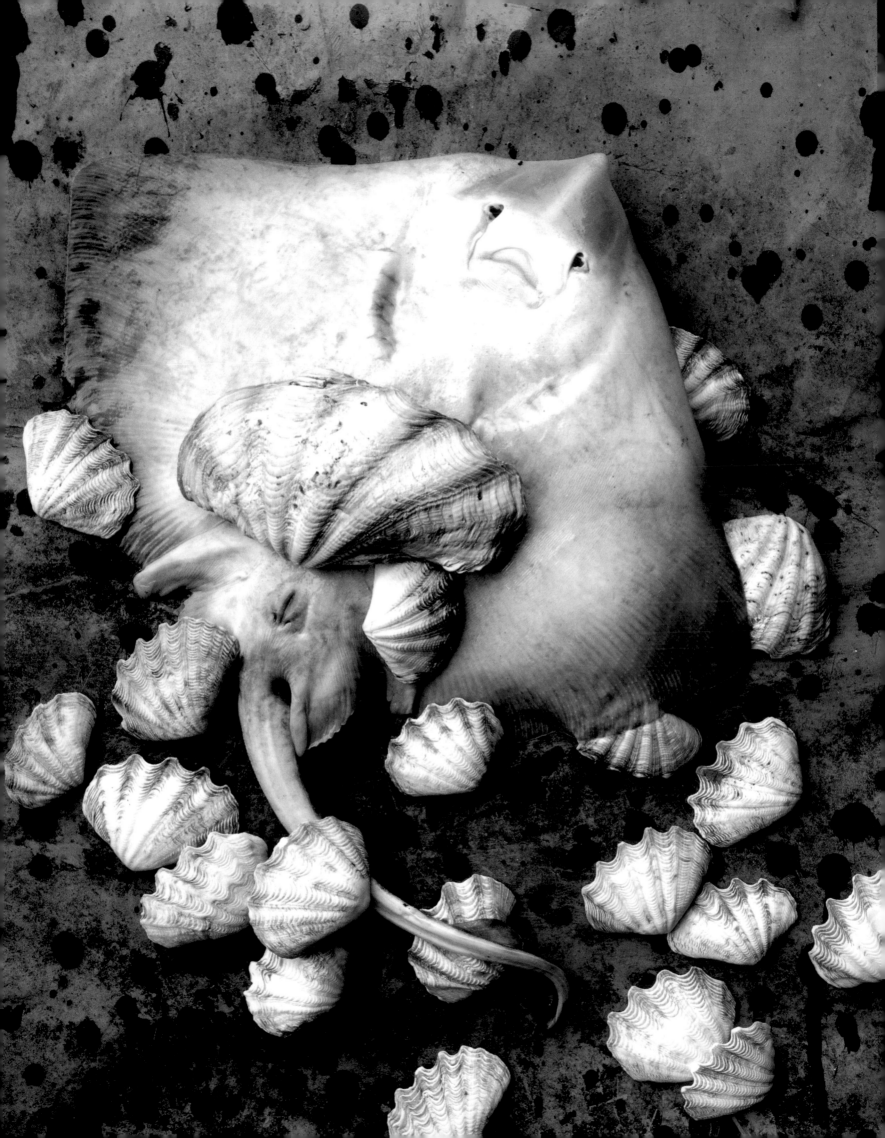

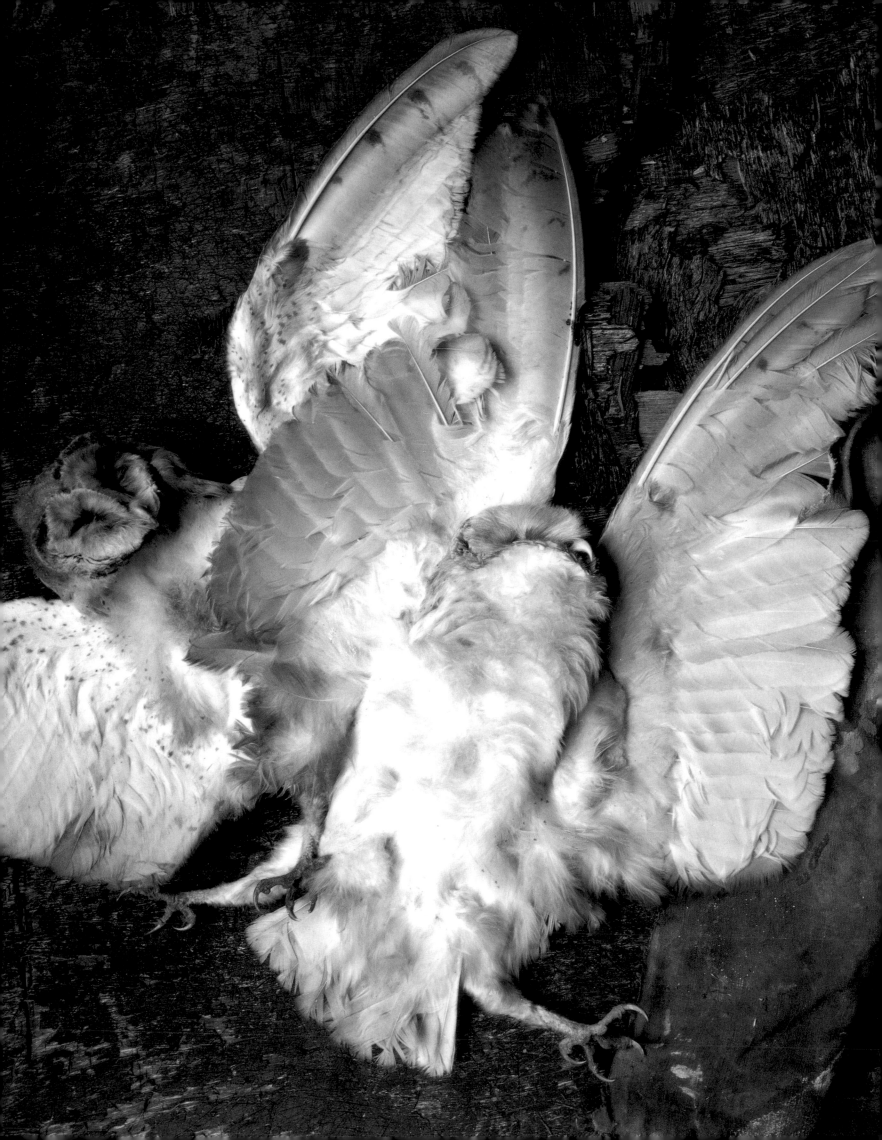

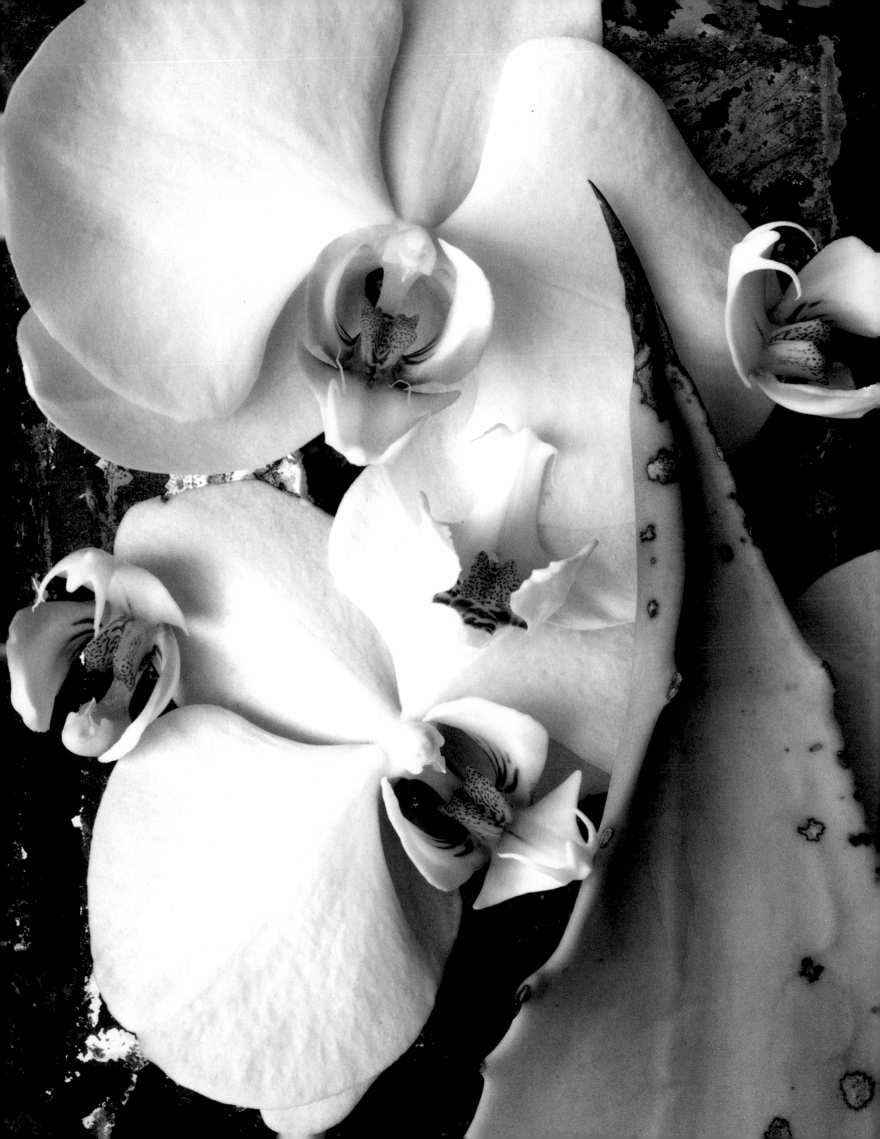

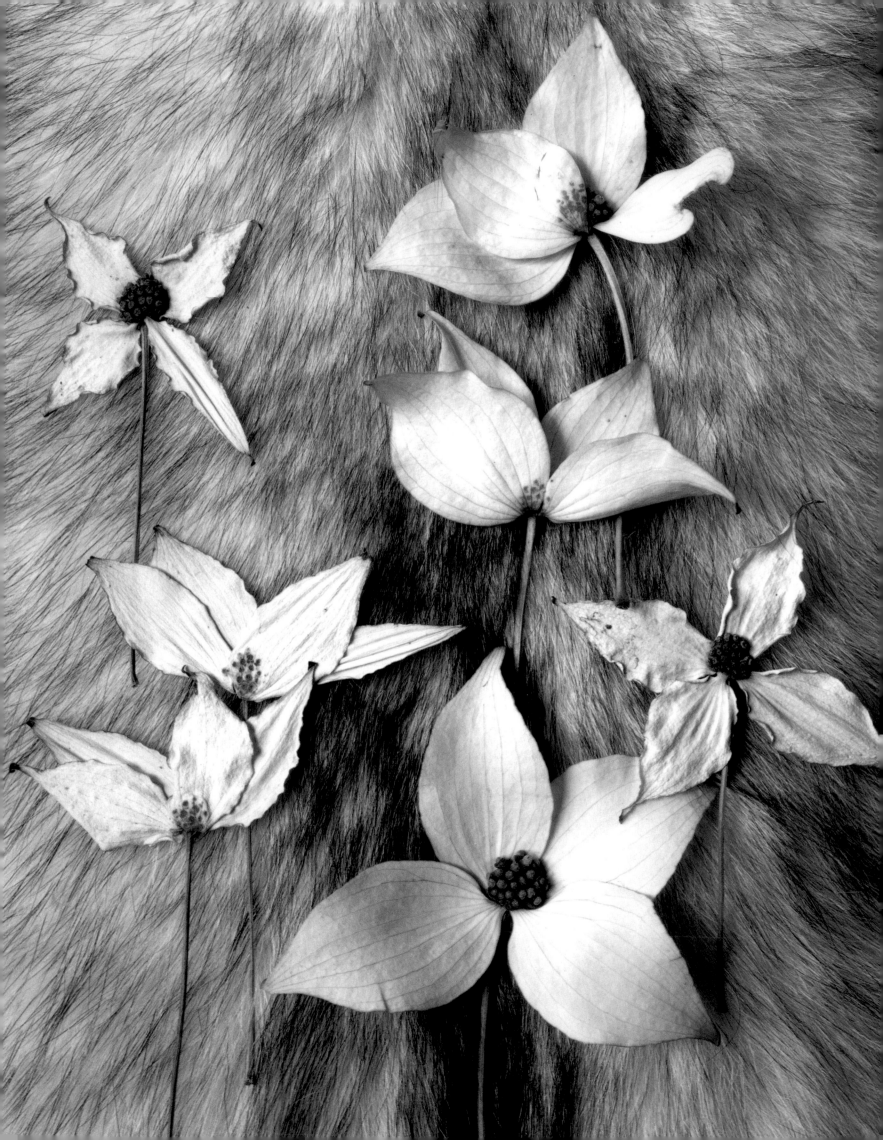

Meadowland 1992

Down in the Pond 1995

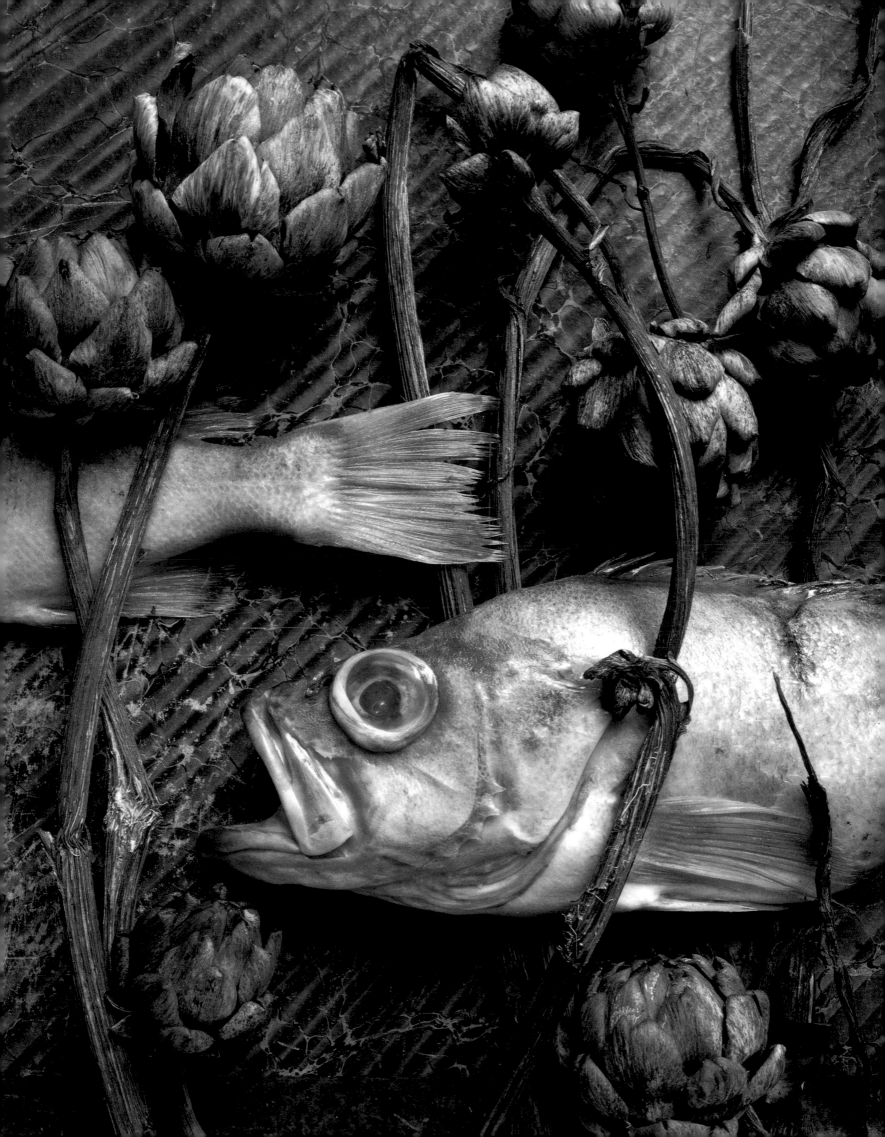

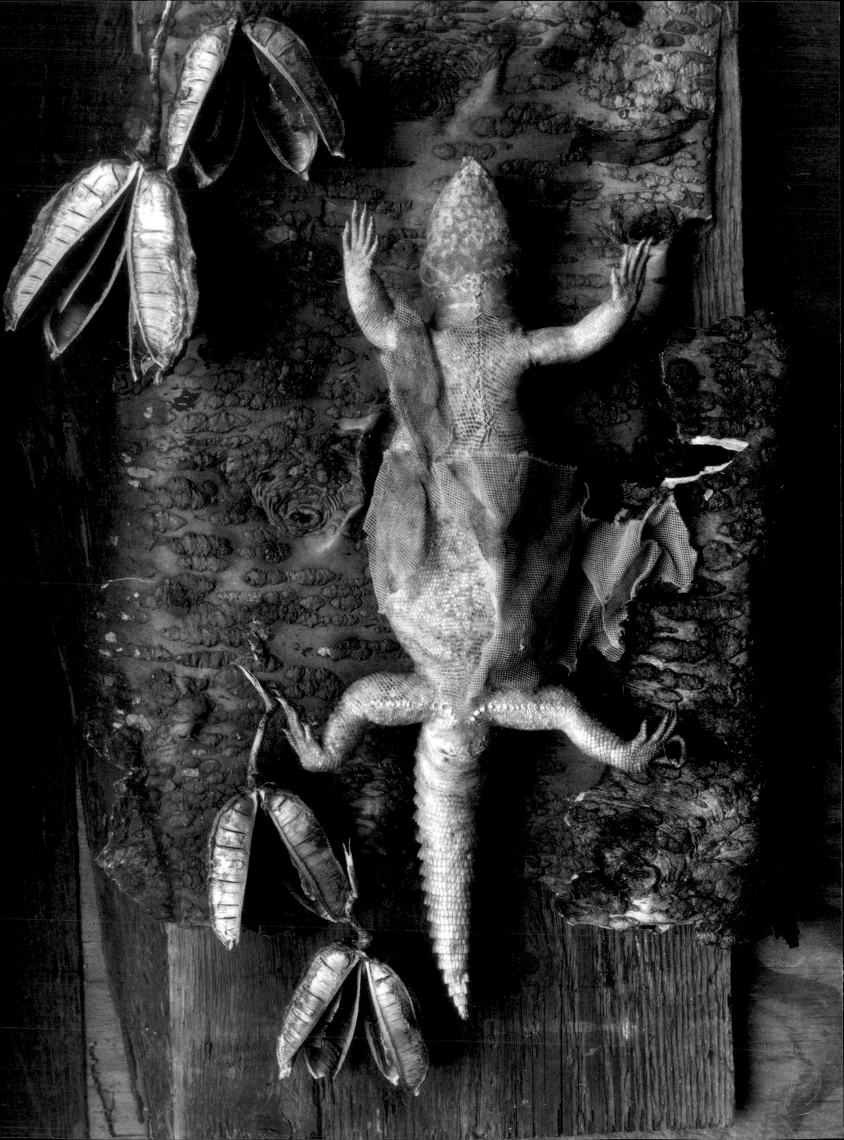

Iguana Skin 1989

Three Feathers 1993

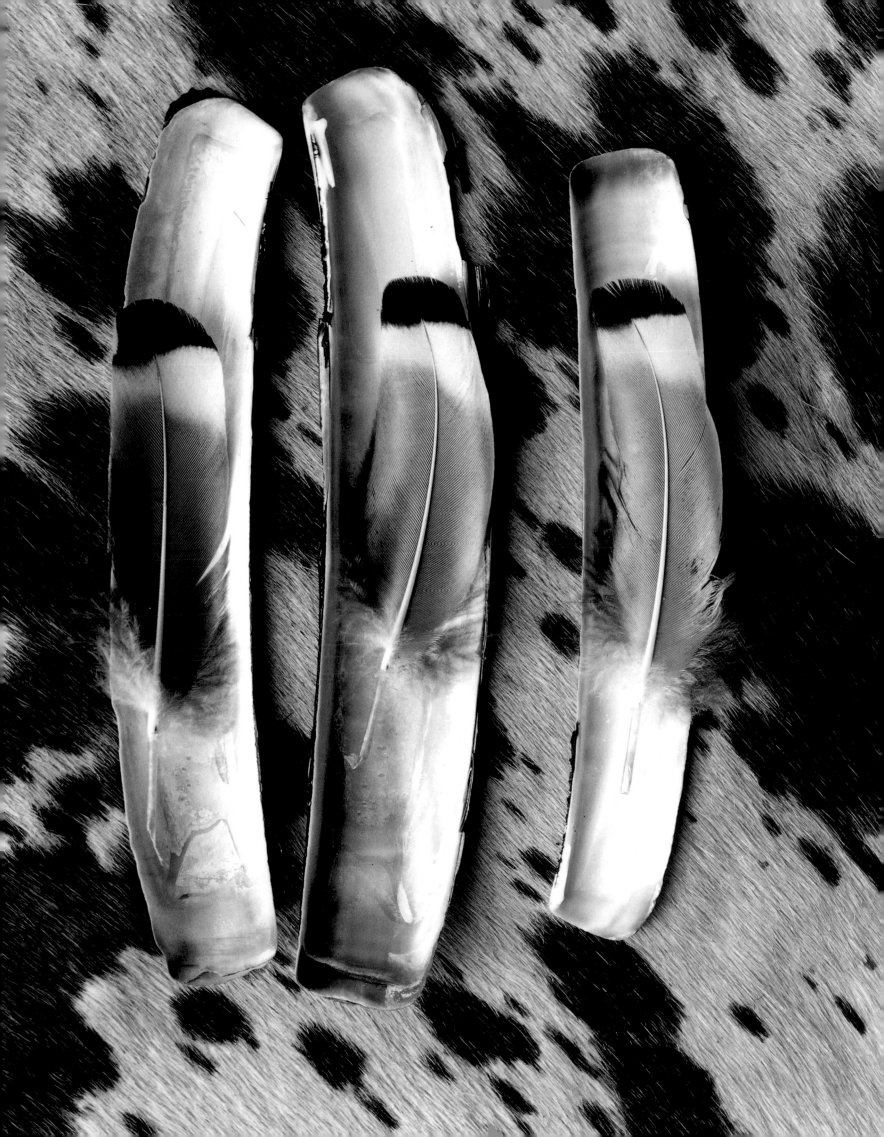

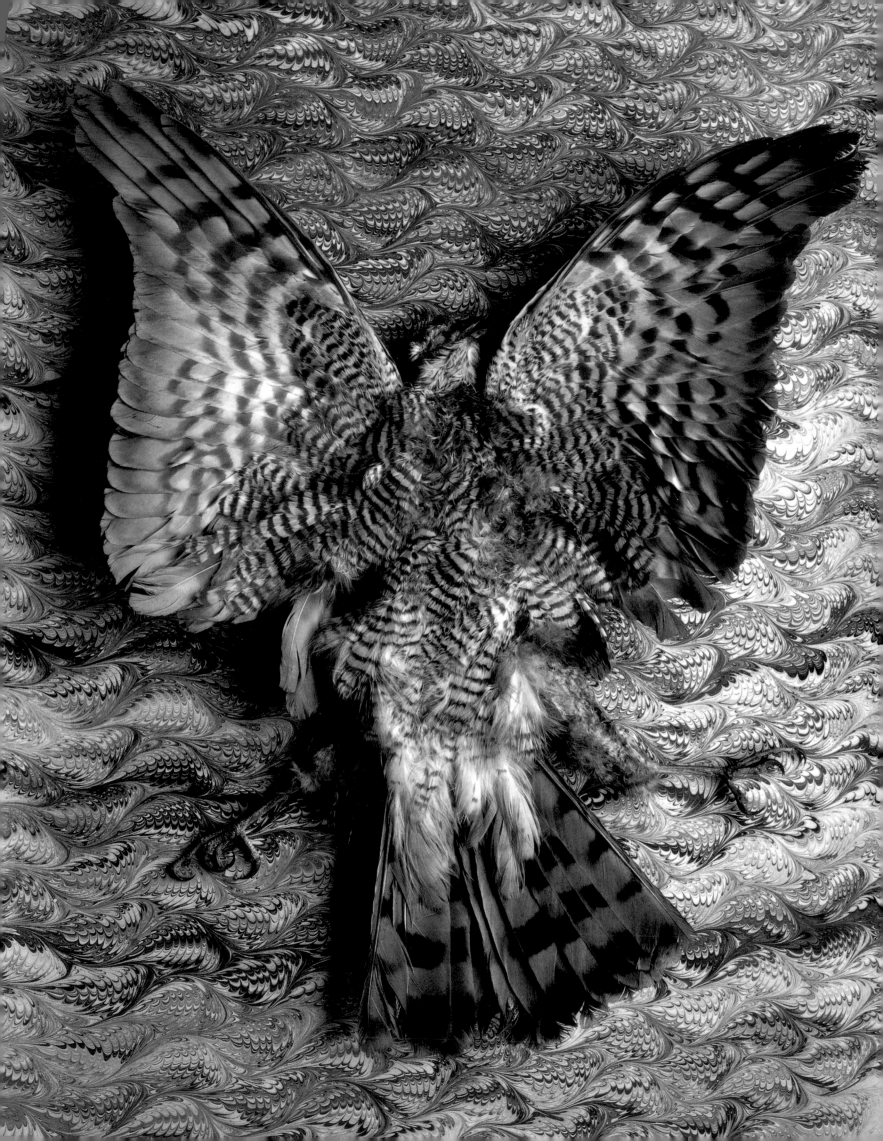

Buzzard on Paper 1995

Ikebana 1989
No Wind 1993
Sharkland 1995

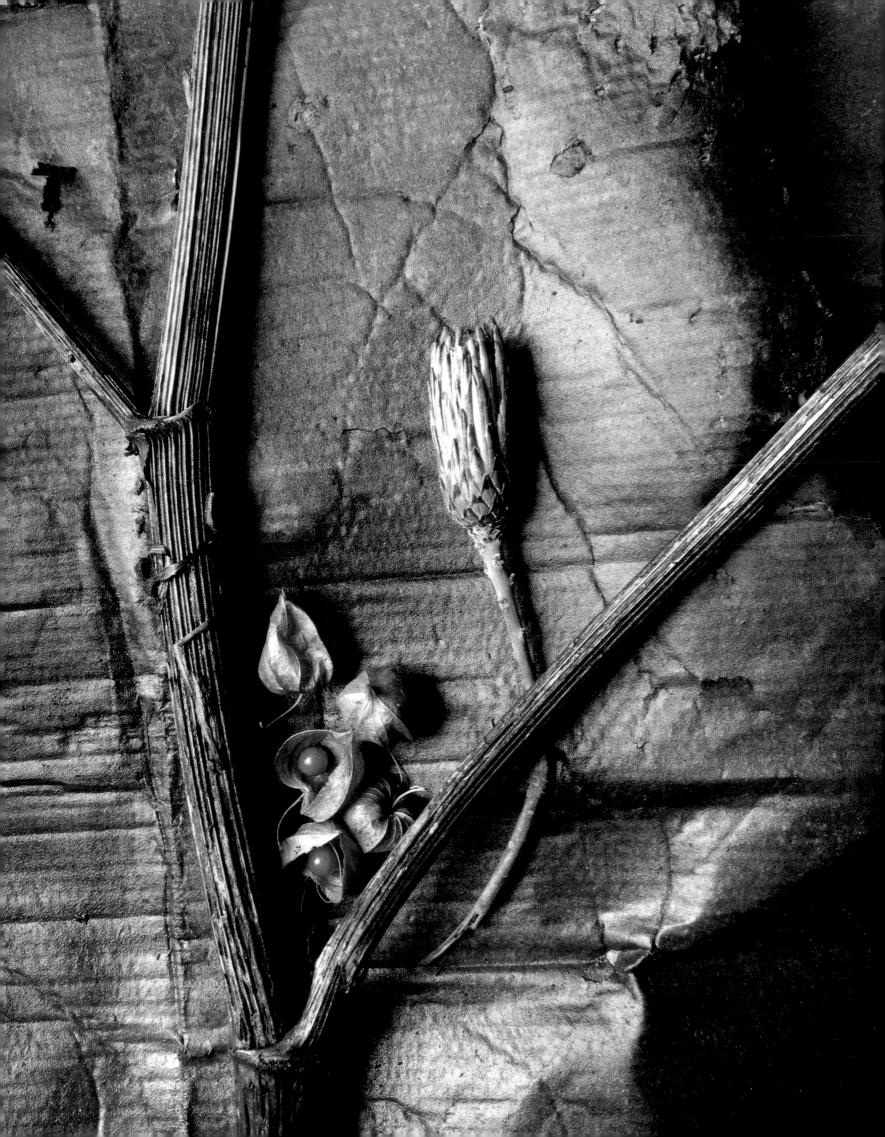

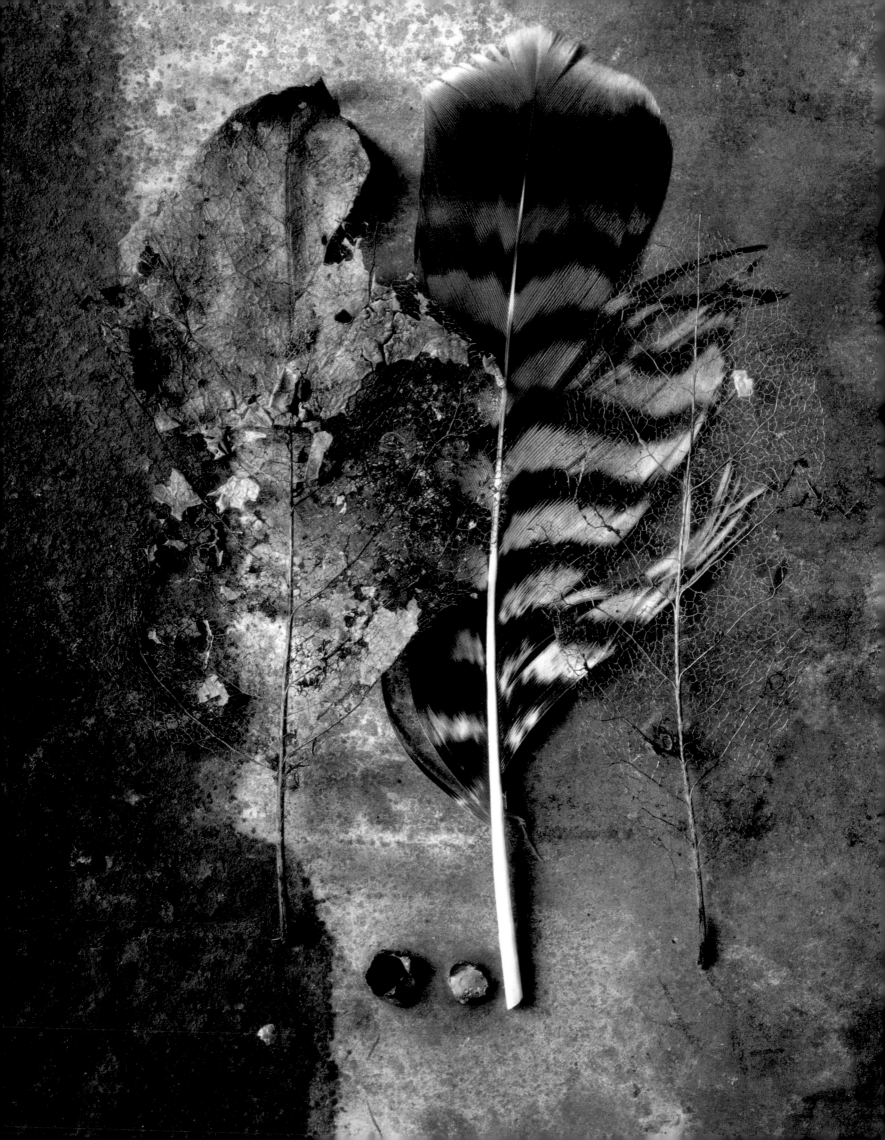

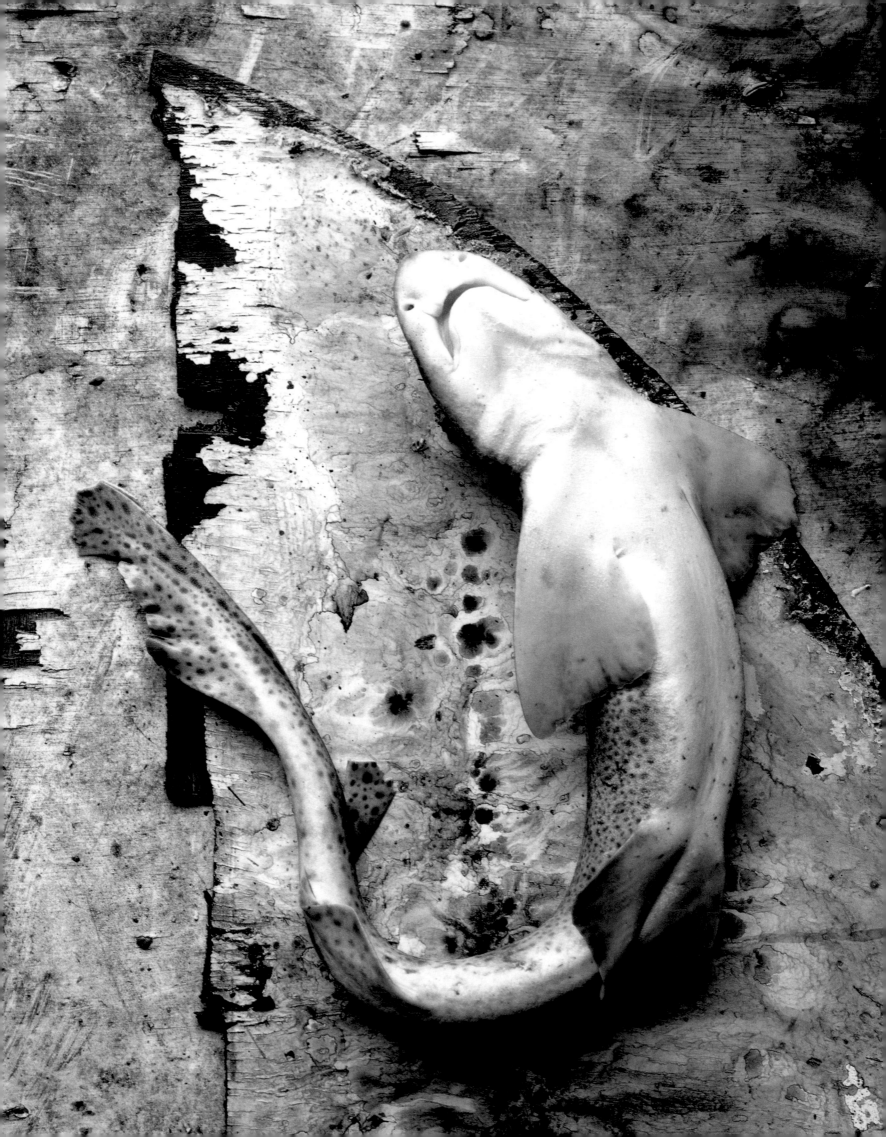

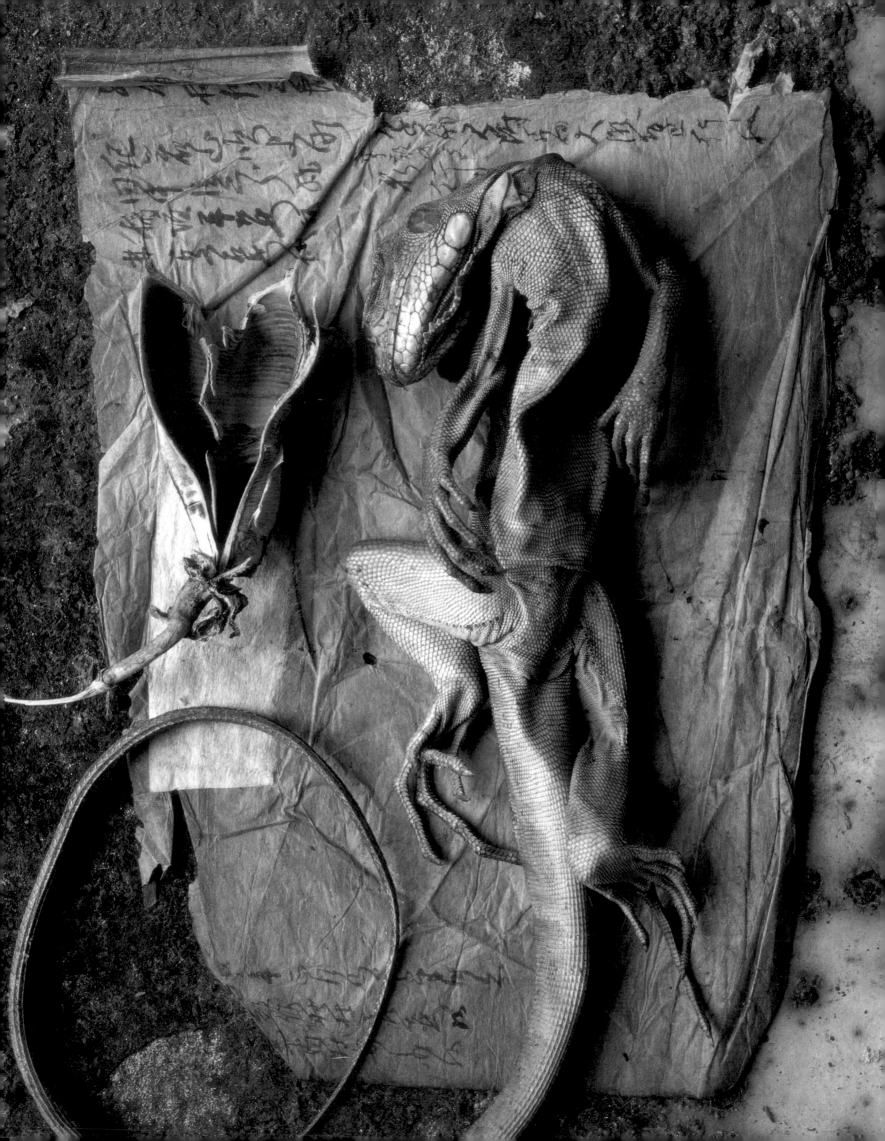

Iguana Visitor 1990

Pair of Shells 1995

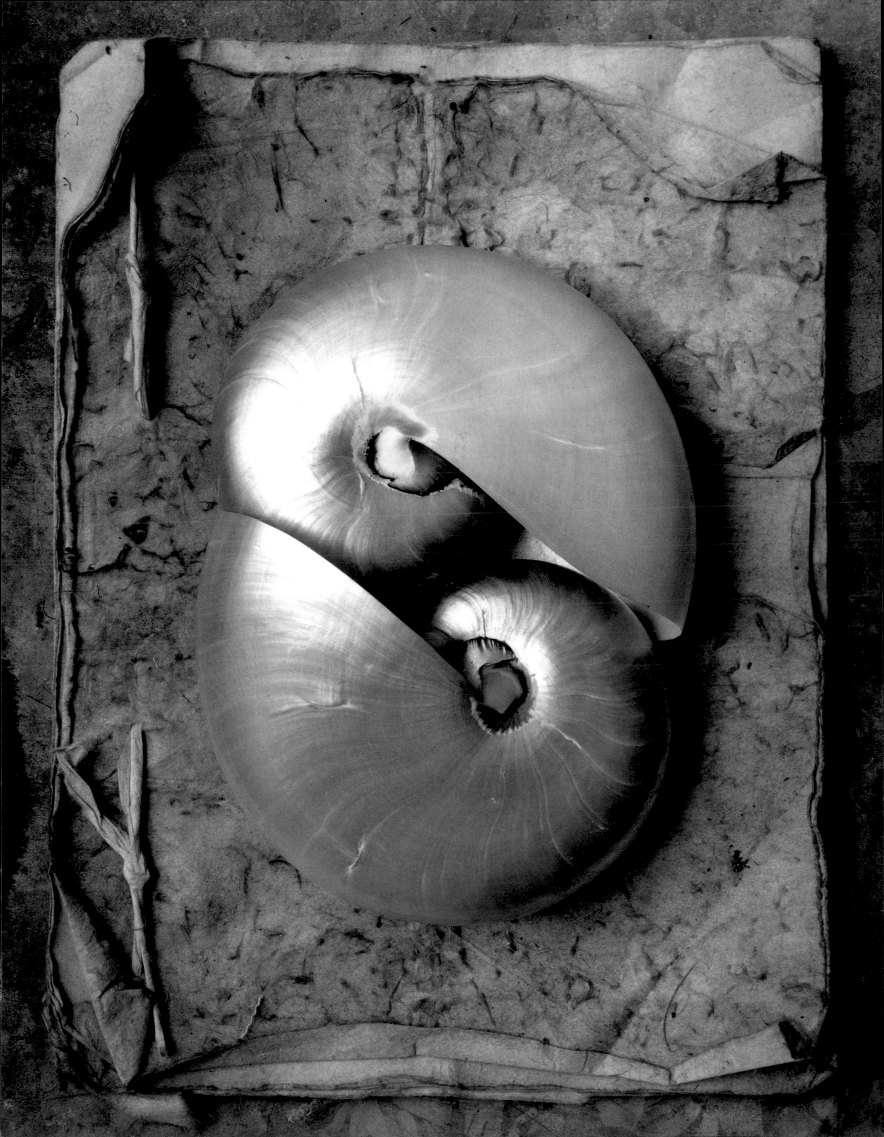

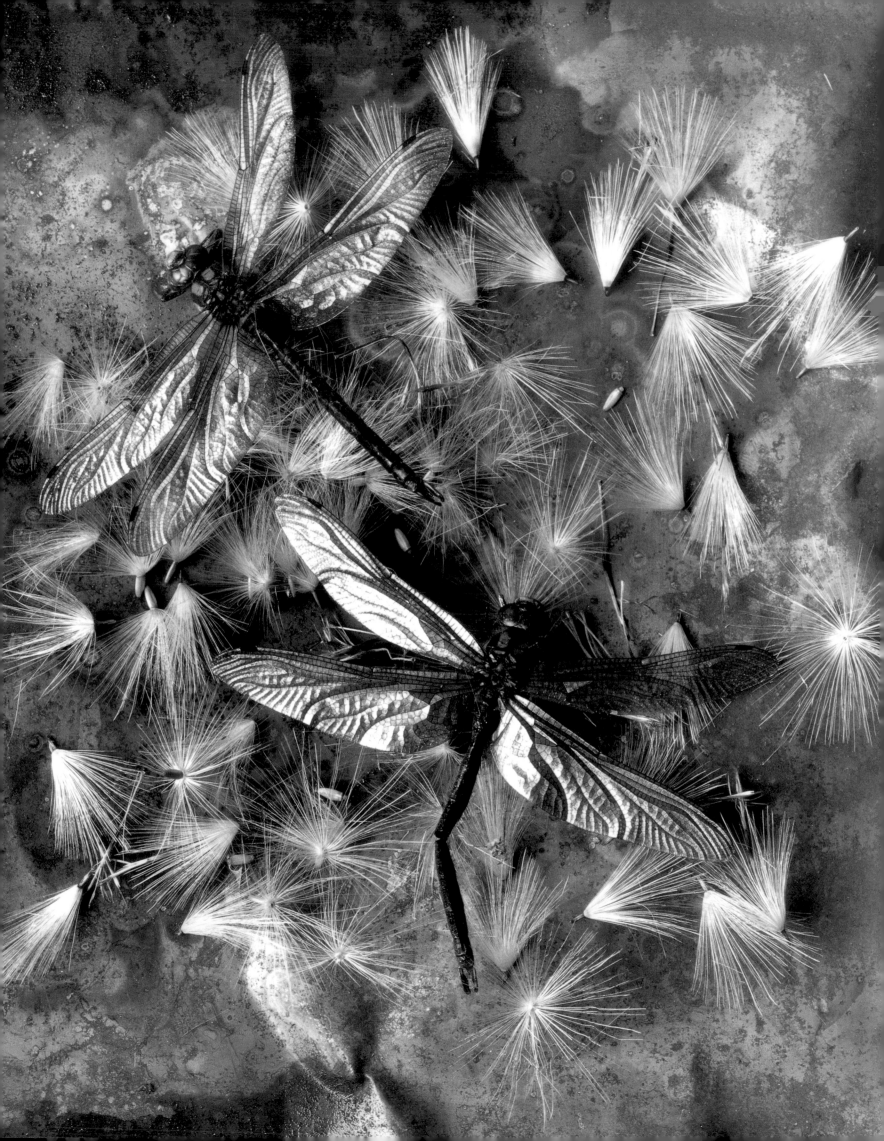

Flying Seeds 1992

Black and White 1995

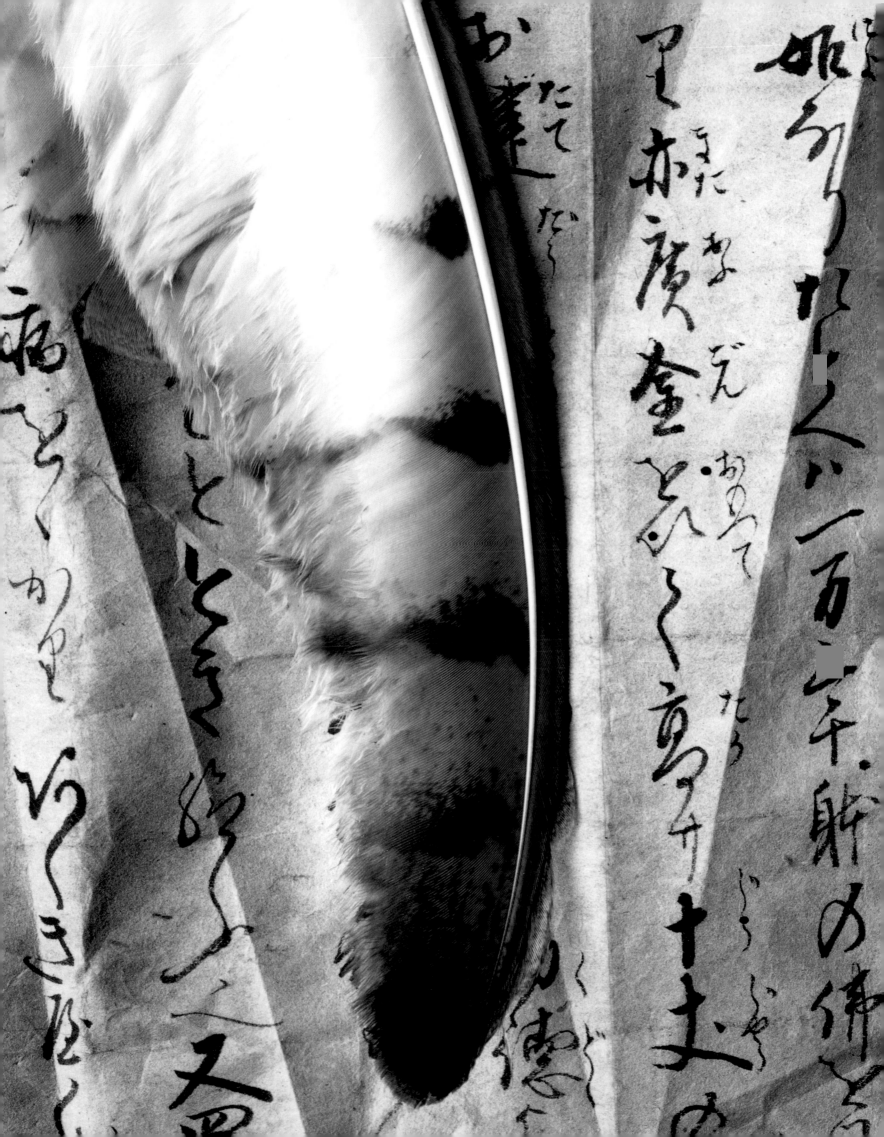

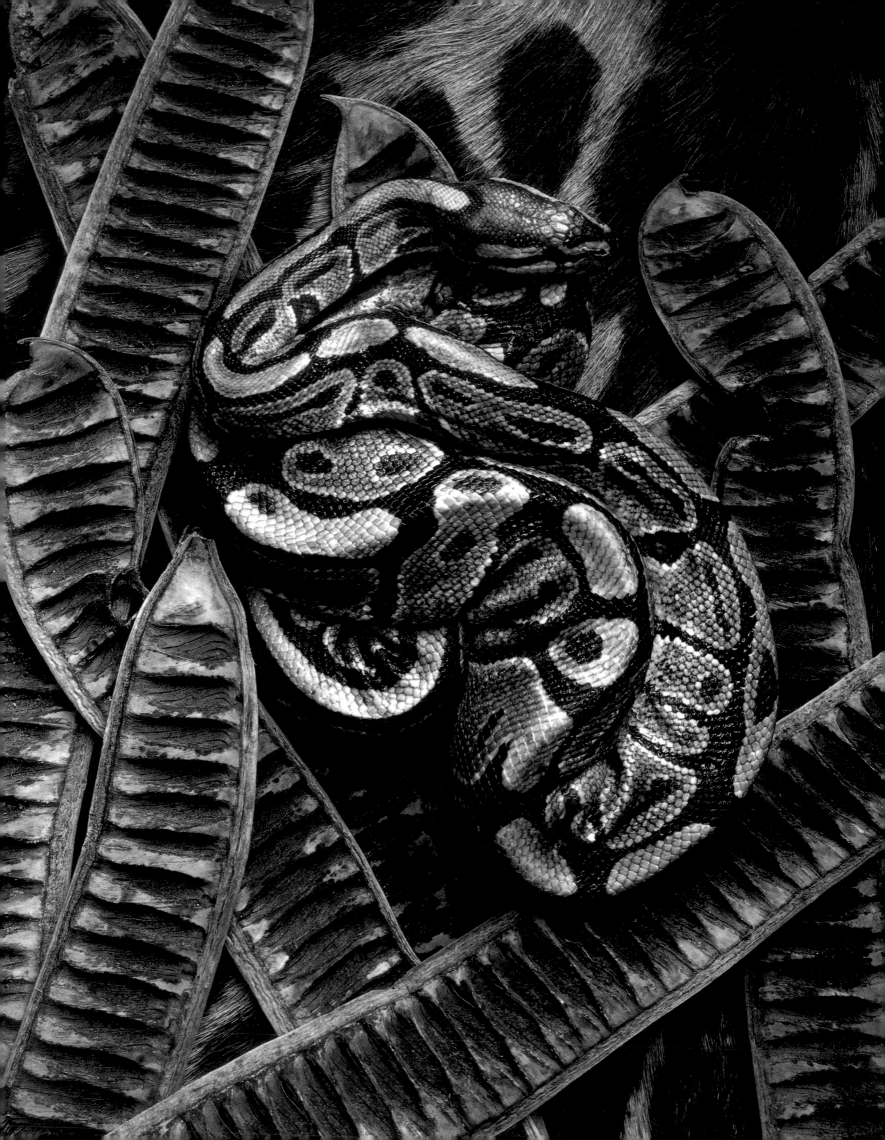

Jungle Fever 1995

Skins in the Sea 1995

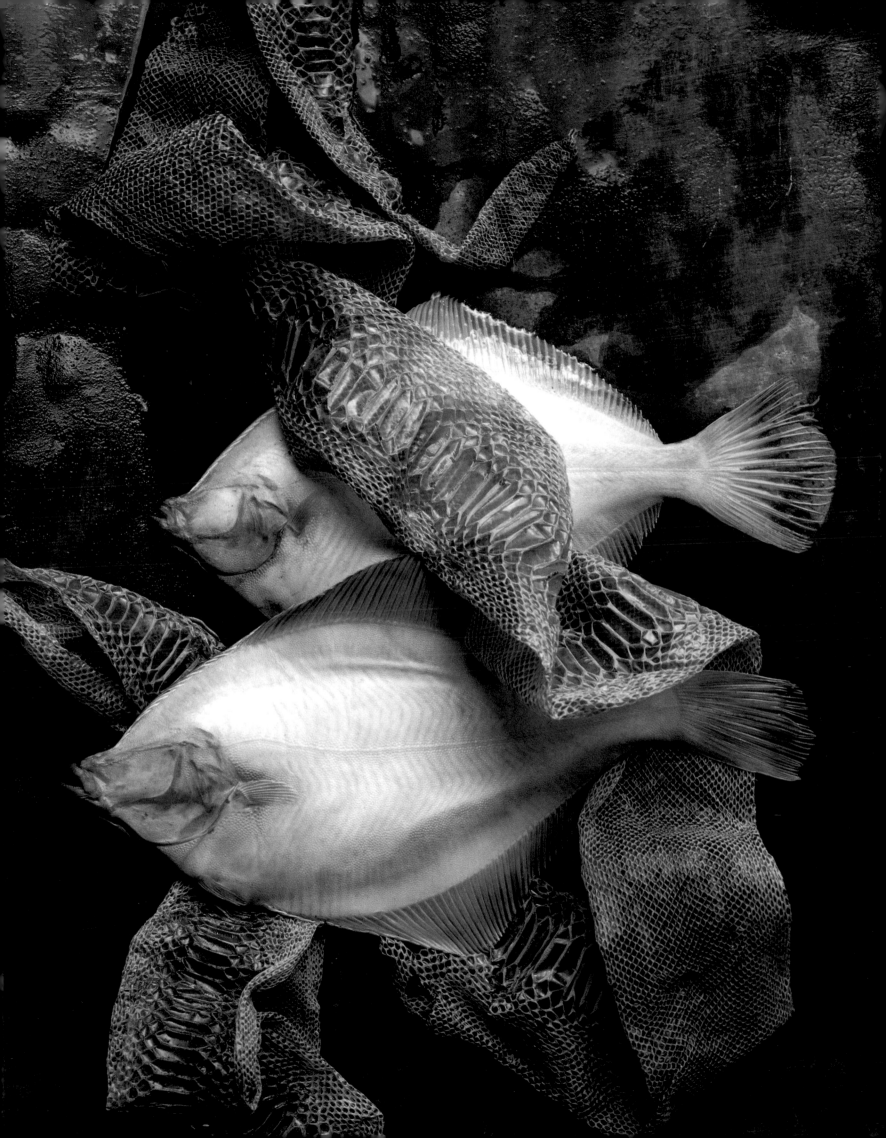

CHRONOLOGY

Vita

Born in Essen, Gemany in 1993

University studies in ethnology, art history and German language and literature

Free-lance photographer since 1978

Co-founder of the "Bilderberg" agency in Hamburg, 1982

Frequent travels and numerous photo-reports on topics of cultural history in Japan, China, Russia, Australia, the Caribbean, Europe and the U.S.

Work on still lives and collages since 1986

Selected Solo Exhibitions

1995 J. J. Brookings Gallery, San Francisco, U.S.A.

1995 Yokohama Tower Gallery, Yokohama, Japan

1993 Fotografie Forum, Frankfurt, Germany

1991 Nikon Galerie, Zurich, Switzerland

1990 Galerie 68 elf, Cologne, Germany

 Haneburg, Leer, Germany

1989 Galerie Rösner, Stuttgart, Germany

1988 Galerie Atelier 1, Hamburg, Germany

1985 Castel Hoensbroek, Hoensbroek, the Netherlands

Selected Group Exhibitions

1994

"Deutscher Photopreis", Rencontres Internationales de la Photographie, Arles, France

1993

"Bilderberg", Carmelite Monastery, Frankfurt, Germany

1991

"New Photography", Museum of Modern Art, New York, U.S.A.

"Der wilde Osten", Internationale Fototage, Herten, Germany

1990

"Der wilde Osten", Historisches Museum Berlin, Germany

"Polaroid Collection", photokina, Cologne, Germany

"Bilderberg", Fotografie Forum, Frankfurt, Germany

Haus der Wirtschaft, Stuttgart, Germany

Rencontres Internationales de la Photographie, Arles, France

1989

"Polaroid Collection", photokina, Cologne, Germany

1987

"America by Day and Night", Fotografie Forum, Frankfurt, Germany

Selected Books and Catalogues

ZEN. Hamburg: Ellert & Richter, 1984.

Amerikanische Nächte. Text by Freddy Langer. Hamburg: Ellert & Richter, 1984.

Japanische Impressionen. Text by Irmtraud Schaarschmidt-Richter.
Schaffhausen: Edition Stemmle, 1988.

Muschelherz und Finkenschlag. Fotografierte Stilleben. Introduction by Bernd Küster.
Schaffhausen: Edition Stemmle, 1991.

Wrecks and Other Beauties. Frankfurt: Fotografie Forum, Frankfurt, 1992.

The Ballad of Rita Tushingham. Text by Peter Gilmour. Schaffhausen: Edition Stemmle, 1993.

Land of Snow. Yokohama: Yokohama Tower Gallery, 1994.

Periodicals

stern, GEO, Vogue, Frankfurter Allgemeine Magazin, Süddeutsche Magazin, Zeit-Magazin,
Capital, Aerone, El Pais

Acknowledgments

I wish to thank Zen Master Kuon Suhara for focus on the essential,

the taxidermist Seiho Kobayashi in Osaka for bird skins and reptiles,

the spider and snake specialist Gerd Kunstmann in Hamburg for the wonderful snake skins,

the Stemmler family in Switzerland for the opportunity to spend time in their museum,

Hans Becker and his wife in Kleve for a long day of stones and shells

and Jürgen Genser for the bird's wings at the last minute.

And thanks, of course, to my children for a thousand little things.

Text copyright by the author

Reproduction copyright by the artist

Translation of the text by Denis Bourgès from the German by Ishbel Flett, all other translations by John S. Southard

Editorial direction by Michèle Thüring

Art direction by Grafikdesign Peter Wassermann and Andrea Hostettler, Flurlingen, Switzerland

Photolithography by cl Colorlito Rigogliosi S.r.l., Milan, Italy

Printed and bound by EBS Editoriale Bortolazzi Stei s.r.l., San Giovanni Lupatoto (Verona), Italy

ISBN 3-905514-87-7

Cover illustrations:

Flounder 1994

Feathers on Decorated Paper 1992